From Architecture to Object

MASTERWORKS

OF THE AMERICAN

ARTS & CRAFTS

MOVEMENT

From Architecture to Object

MASTERWORKS
OF THE AMERICAN
ARTS & CRAFTS
MOVEMENT

Introduction by Richard Guy Wilson

Dutton Studio Books

In association with

Hirschl & Adler Galleries New York

EXHIBITION DATES

Hirschl & Adler Galleries, New York
October 7–November 18, 1989

Struve Gallery, Chicago
December 15, 1989–January 22, 1990

DUTTON STUDIO BOOKS

Published by the Penguin Group
Penguin Books USA Inc., 375 Hudson Street,
New York, New York 10014, U.S.A.

Penguin Books Ltd, 27 Wrights Lane,
London W8 5TZ, England

Penguin Books Australia Ltd, Ringwood,
Victoria, Australia

Penguin Books Canada Ltd, 2801 John Street,
Markham, Ontario, Canada L3R 1B4

Penguin Books (N.Z.) Ltd, 182–190 Wairau Road,
Auckland 10, New Zealand

Penguin Books Ltd. Registered Offices:
Harmondsworth, Middlesex, England

First published by Dutton Studio Books, an imprint of
Penguin Books USA Inc.

First printing. January, 1991
10 9 8 7 6 5 4 3 2 1

Design: Elizabeth Finger
Editor: Sheila Schwartz
Typesetting: Characters Typographic Services, Inc.
Printed and bound by Dai Nippon Printing Co., Ltd.,
Tokyo, Japan

Catalogue entries:
Douglas Dreishpoon (cats. 1, 4, 25, 27, 38, 39, 41, 48–53, 63,
64, 71–79, 88, 111–15)
Sandra K. Feldman (cats. 29–37, 65, 80, 87)
Michael FitzSimmons (cats. 2, 6, 42–45, 54, 59, 60, 70)
Janet A. Flint (cats. 91–95)
Joseph Goddu (cats. 96–110)
Ann Yaffe Phillips (cats. 3, 7, 11, 12, 40, 55–58, 61, 62, 66–69,
81–86, 89, 90)
Meredith E. Ward (cats. 5, 8–10, 13–24, 26, 28, 46, 47)

All photographs are by Helga Photo Studio, Upper Montclair,
New Jersey, with the following exceptions: cats. 19–22, 29, 30,
76, 77 by Bakal-Schwartzberg Studios, Inc., New York; cat. 40
by Sixth Street Studio, San Francisco, California; cats. 2, 6, 11, 12,
42–44, 54, 58, 59, 60, 68, 70 by Michael Tropea; and cat. 55 by
Christie's, New York

Library of Congress
Catalog Card Number: 89-80793

Printed and bound by Dai Nippon Printing Co., Ltd.,
Tokyo, Japan

ISBN: 0-525-24940-0 (cloth); ISBN: 0-525-48586-4 (DP)

Contents

Notes to the Catalogue

Dimensions are in inches; height precedes width precedes depth. Full references to abbreviated citations appear in the bibliography beginning on p. 154.

Foreword

When transplanted to American soil, the English Arts & Crafts Movement, with its mixture of future-oriented, reformist ideals and a backward-looking romanticization of the unity and simplicity of medieval life, took on a further dichotomy. The American movement, buoyed by an optimism for the future and an eagerness to break away from heavy, ornate Victorian design, combined the desire for simplicity with the potential of machine technology. Whereas the English relied heavily on notions of handcrafted objects and disdained the use of machines, American designers and architects—including Gustav Stickley, Elbert Hubbard, Frank Lloyd Wright, and Charles and Henry Greene—had no such prejudices. In the workshops and factories making furniture and objects in the Arts & Crafts style, the urge for the handcrafted was combined with efficient American know-how based on the latest production methods. Frank Lloyd Wright, whose primary concern was design, recognized the aesthetic value of machine-made objects; others, like Stickley, combined machine construction with hand-finishing. And Elbert Hubbard claimed that all Roycroft products passed under the hand of the craftsman. It is reported that Dirk Van Erp, himself a stickler for handcrafting, responded by suggesting—with a touch of irony—that Hubbard probably stood on a bridge over the railroad tracks as trains laden with Roycroft merchandise passed beneath his outstretched hands.

In addition, the urge for reform became, in the United States, one of progress and exploration, coupled with a comforting simulation of history. In the still-new republic of the United States, just over a century old in 1900, designers turned to their country's own Colonial roots in search of a new, simplified style, while at the same time adopting the medieval precedents of the English Arts & Crafts Movement.

These historical references, combined with a progressive, rationalistic pursuit of new design and technology, resulted in a style that in its urge to simplify and willingness to synthesize was modern in spirit. Indeed, when we examine some of the objects produced during this period, with their simple lines and visible structure, we cannot help but marvel at how modern they appear. What besides material separates a settle by Gustav Stickley from a *grand-confort* loveseat by Le Corbusier? The best design from the Arts & Crafts period has a special resonance which echoes through the intervening decades to our present day.

After many decades of neglect, the furniture and designs of the American Arts & Crafts Movement are currently undergoing an intensive reexamination and rediscovery. Like others, we too have turned our attention to the handsome proportions and simplified lines found in the work of some of the most important architects and designers of our century. It is the purpose of this exhibition to present objects by those American Arts & Crafts architects, designers, craftsmen, and photographers who contributed to the explosion of fresh artistic ideas occurring in the decades around the turn of the century. The exhibition is not intended as a historical survey; we have gathered together examples of what we consider to be the best available work produced in the American Arts & Crafts style. It is our hope that the exhibition reveals the breadth and innovation of American Arts & Crafts design.

MICHAEL FITZSIMMONS
ANN YAFFE PHILLIPS
JAMES L. REINISH

EXHIBITION ORGANIZED BY:

Stuart P. Feld

Ann Yaffe Phillips

James L. Reinish

CATALOGUE COORDINATED BY:

Douglas Dreishpoon

Ann Yaffe Phillips

PREFACES, CATALOGUE ENTRIES
AND RESEARCH BY:

Douglas Dreishpoon

Sandra K. Feldman

Michael FitzSimmons

Janet A. Flint

Joseph Goddu

Ann Yaffe Phillips

Meredith E. Ward

Acknowledgments

Although Hirschl & Adler has had a long involvement with the decorative arts, this is the first exhibition the gallery has mounted that is devoted exclusively to the field of design. As such, it has required collaboration on many levels, both among our staff and outside the gallery. We wish to thank and acknowledge all those who contributed to helping us bring this exhibition before the public.

Special acknowledgment must be given to Michael FitzSimmons of Struve Gallery, who not only helped to organize the show, and in so doing participated in the many conversations which shaped the exhibition, but also assisted in locating works of art and made available his expertise and good advice on numerous occasions.

We would also like to thank Richard Guy Wilson for contributing the introduction to our catalogue, as well as those who generously lent works to the exhibition, led us to specific pieces, and availed us of their time and expertise: Bryce Bannatyne, Jr., Anthony DeLorenzo, Scott Elliott, Paul Fiore, Whitney Ganz, David Gebhard, Stephen Gray, Raymond Groll, Wilbert Hasbrouck, George and Rosemary Lois, Harry H. Lunn, Jr., Don Magner, Randell L. Makinson, Richard Manney, Nancy McClelland, Barbara Michaels, D.J. Puffert, Tim Samuelson, Jo C. Tartt, Jr., and Tod Volpe.

On the Hirschl & Adler staff, we would like to single out for special thanks Bill Blatz, Sandra K. Feldman, Janet A. Flint, Joseph Goddu, Mary Sheridan, Richard Sica, Elizabeth Stuart, and Meredith E. Ward.

DD
AYP
JLR

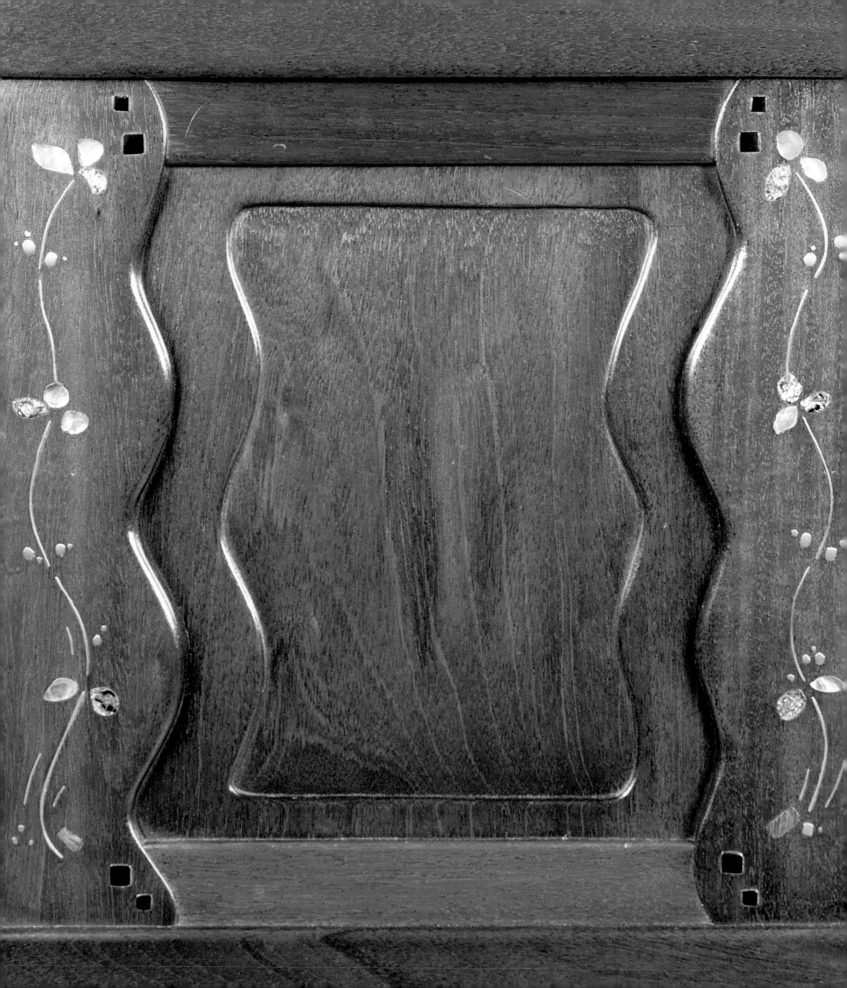

Introduction

Entry into the world of the Arts & Crafts can be through a door of finely wrought mahogany filled with Tiffany glass, or a door of dark oak planks bound with large, hammered brass hinges, or a door of light oak with a carved oak-leaf cluster in the middle. These possibilities provide a clue to the diversity and complexity of the Arts & Crafts Movement, while at the same time indicating the overwhelming quest for a totality of expression.

The Arts & Crafts Movement was never a single style or image, but rather a mood, a consciousness, a state of mind, ascetic in appreciating simplicity and yet profligate in details. And what details! Run your fingers over the surfaces of a Greene and Greene chair, the sensuous and smooth mahogany, the delicate carvings, the hard ebony pegs, the inlaid mother-of-pearl with wire stems. Then turn to a Gustav Stickley high-back settle: the oak has a completely different feel, harder, with more grain, the corners are more emphatic, and the detail coarser, with prominent pegs and butterfly joints. One should hold and caress the leaves of a Teco pot, or the beaten copper on a Van Erp vase. These objects were not created to be admired from afar, as rarefied pieces of art. Nor were they purely functional, mass-produced objects—sold, used, and then discarded. These are objects created as art but also intended to be a part of life. Though the tactile is one level of the Arts & Crafts, the pieces, whether a Harvey Ellis chair or an Arthur Wesley Dow print, are also mediums for contemplation and reverie, for opening oneself to a new world, both inward and outward.

Many Arts & Crafts items involve an almost religious or mystical sensibility: one senses the commitment of their makers; these seemingly practical works transcend mere functionality by inducing an oneiric, or a daydreaming response in the viewer. The Grueby *Pine Tree* tiles (cat. 33) are not realistic, but "conventionalized" abstractions of nature. The flattened forms, the broad, sweeping panorama of a gentle landscape portrayed in green and various hues of blue, and the framing pines with their horizontal limbs engender a reverie of calmness and peace. The Arts & Crafts houses by Frank Lloyd Wright and the others were created as havens of retreat and vehicles for the contemplation of a higher reality.

The place of the Arts & Crafts impulse in the history of American art is finally being accorded its rightful position as one of our most important and vital expressions.[1] There have been historians who reflect a Hegelian-Positivist universe, who see the importance of the Arts & Crafts only insofar as it presupposes mid-twentieth-century modernism. Certainly there is

Charles Sumner Greene and Henry Mather Greene
Sideboard, Blacker house (detail). CAT. 74

furniture and sculpture produced in the mid-twentieth century which recalls the geometrical simplicity of a Jarvie vase or a Stickley chair. And to further confuse the issue, some of the Arts & Crafters argued that their art was "modern." Arthur Wesley Dow's great poster for Prang advertises "Modern Art (cat. 100)." Frank Lloyd Wright used the word "modern" to describe his work. Yet most of the objects of mid-twentieth-century American modernism portray an impersonal, anonymous, and mechanophile character and completely disregard the original intent of Arts & Crafts designers such as Dow and Wright, who always remained tied to specific locations, to the "place where"—whether Ipswich or the prairie—and to human content.[2] The importance of the Arts & Crafts lies not as a transition leading to something else, but within itself; it has its own intrinsic value. It stood as a call for reform in how life was lived and for the creation of a great, new art.

In this call for reform, the effect was felt not just by architecture and the decorative arts, but also in painting, graphics, and photography, all of which were frequently shown in Arts & Crafts exhibitions. Will Bradley used a similar technique of flat, layered forms for his interiors for the *Ladies' Home Journal* and for posters. Stickley admired the ennobling photographs of the American Indian by Edward Curtis (cat. 111) and frequently illustrated his work in *The Craftsman*. Landscapes by Tonalist painters, who sought a meaning that went beyond mere appearance, resemble the Grueby *Pine* tiles and were favored by Arts & Crafts designers and patrons. The misty, soft-focus photographs of Edward Steichen, Alfred Stieglitz, and other Pictorialists have a definite correspondence in both subject matter and intent with the Arts & Crafts Movement. Steichen created a romanticized new world that is not just blurred nature and workers, but a dreamy pastoral landscape of promise and divinity. There is a seductive power in Steichen's landscapes; the shadows and forms, though recognizable, seem to be of another world.

Without too many qualifications one can argue that the Arts & Crafts Movement represents our most illustrious attempt at forging a national aesthetic in the arts; at creating an American art while recognizing the polymorphous, heterogeneous, and individualistic nature of this vast country. Yes, the Arts & Crafts Movement in America has paradoxical elements, for it is part of a larger turn-of-the-century international concern for reform in the arts and owes a great deal both stylistically and philosophically to foreign sources. Americans have always been acquisitive and the Arts & Crafts is no exception. But ultimately American Arts & Crafts encom-

Will H. Bradley. *Drawing for Library*, watercolor on paper, mounted on linen. Courtesy, Henry E. Huntington Library and Art Gallery, San Marino, California

passes some of our greatest artists, who created an art different in form, content, and ideals from that of Europe.

The American Arts & Crafters wanted to make great art that would rival the best of Old World architectural landmarks, paintings, objects, and cabinetwork. Compete with and, ultimately, outdo Europe, but not by copying. The solution of the Americans was to formulate a new definition of art: rather than enshrine art in templelike museums, it would be placed in the home, made available and livable. One result was the idea of the talented amateur. Stickley's *The Craftsman*, Edward Bok's *Ladies' Home Journal*, and similar magazines promoted the homemaker who did stitchery and the man in his woodworking shop making furniture. They expanded the idea of what should be considered as art: art was not simply the rarefied Old Master, but the garden, quilts, stencils, and other objects of everyday, everybody's life. Amateur art clubs that promoted this approach are as much a part of the new consciousness as are the better known Arts & Crafts societies in Chicago, Boston, Rochester, and elsewhere.

From this side of the Atlantic, European classicism of the Renaissance appeared as a "setting sun" which too many Americans had mistaken for "dawn," claimed Frank Lloyd Wright; it was "decadence," "lifeless and bare," a "chill," no longer "indigenous," but "pseudo-classic."[3] Arthur Wesley Dow believed that European methods of art education were too much like a "scientific drill"; the student lacked an appreciation of the essentials of any art: beauty and the spiritual. To reinstall this appreciation meant, for Dow, restructuring the entire way art was taught in order "to think of a picture first as pure design, secondly and subordinately as Representation." His system of creating art—of originating a new type of composition based upon "rhythm and harmony, in which modeling and nature-imitation are subordinate"—became extremely popular in art schools and helped to reshape American product design.[4] Dow, Wright, and the others did not only establish new methods for making art and new images; it was an art that at its best could rival anything the Old World had produced.

In many ways the American Arts & Crafts quest for the creation of an American art went back to 1776. From the declaration of the break with England, and indeed even before, the belief had grown that America was different from the Old World and should have its own culture and art. Throughout the post-Revolutionary period and well into the nineteenth century, many critics, novelists, poets, architects, painters, and other artists tried to characterize American art. The Hudson River landscapists, the novels of the American frontier, wooden cottages, and American prowess with iron and steam in locomotives or the huge Corliss engine at the Philadelphia Centennial were interpreted at various times as uniquely American. Horatio Greenough searched for indigenous qualities, as did Walt Whitman, William Cullen Bryant, Ralph Waldo Emerson, and others; struggling, writing, and sometimes crying into a void for Americans to recognize their own genius and special possibilities. Although one might claim that a reproduction of a Greek temple that served as a state capital building or courthouse gave new meaning to the classical style, or that a landscape of the Yosemite Valley illustrated a new American scale and a reverence for nature, still the forms and the methods were those of the Old World.

Some Americans believed a break could never be made with Europe; America would always be the child walking in its parents' footsteps. Contemporary with the development of the Arts & Crafts came another sensibility, that of the American Renaissance, which held that the importation or reproduction of European palazzi, châteaus, Old Master paintings, Louis XVI furniture, and bric-a-brac should be the foundation of American art. This position was strenuously argued by individuals as diverse as John La Farge, Charles F. McKim, Edith Wharton, and Isabella Stewart Gardner. Given time and through adaptation—the argument went—Americans would create a new art based upon the European classical precedent. With perspective we can see that this did indeed occur: the art of the American Renaissance and its aftermath into the 1920s and 1930s is different from its European antecedents while still retaining a very obvious family tie.[5]

Through the nineteenth and well into the twentieth century nearly every Western country entered into the debate over, and the search for, an appropriate national character in the arts. The concern with artistic identity existed at other levels as well—among submerged minorities such as the Finns (under the Russian czars) and the Slavonians (under the Austro-Hungarian Empire), and at the regional level, from Scotland to the Midwestern prairies and southern California. This search for an identifying expression came as the legacy of nineteenth-century nationalism, with its mandate of allegiance to one's homeland or cultural group. Instead of the earlier dynastic and religious affiliations, now citizens looked for national identification, preferably one with a historical basis. Nearly every country claimed versions of classicism, medievalism, realism, naturalism, and other styles as their own, or manufactured new ones. For those in the United States con-

cerned with such questions, the lack of a long history produced two reactions: either copy Europe, or turn to nature, the landscape, industry, or political beliefs which had recognizable American features.

The Arts & Crafts Movement existed as part of this international concern with national identity. Although many individuals, from the German philosopher Johann Herder to the French architectural theorist Viollet-le-Duc, contributed to the ideology of the American branch of the Arts & Crafts, still the major contribution came from England and the legacy of Carlyle, Pugin, Ruskin, and especially William Morris. Frank Lloyd Wright, who rarely acknowledged any influence, proclaimed: "All artists love and honor William Morris."[6] Morris, as a middle-class reformer appalled by the low quality of machine-manufactured goods, attempted to reintroduce *quality* design and craftsmanship into products for the home. His interests were protean. From textiles to furniture, from architecture to book design, from stained glass for churches and the home to the writing of poetry and essays, Morris attempted to restructure English life. He was the catalyst and the leader, but he also had talented associates: those close to him such as Philip Webb, William R. Lethaby, and Charles R. Ashbee, and those more removed, such as C.F.A. Voysey and Charles Rennie Mackintosh. Wright and many of the other American Arts & Crafters saw in Morris an apostle of "the new art," of an argument for the "gospel of simplicity" and "elimination."[7] Morris stood for an art based on local circumstances, an art inspired by the English vernacular and organic motifs, not by eclectic borrowings from foreign cultures.

Morris' new art had several premises. He stood for the unity of the craftsman and the artist and maintained that a fallacious distinction existed between the major—or high—arts, such as painting, sculpture, and architecture, and the lesser arts, such as furniture, metal craft, and textiles. The lesser arts were life, they were what we live with. Morris also argued for simplicity, but that did not mean bareness or lack of ornament. He was a craftsman and claimed that an object "has always been thought to be unfinished till it has had some touch or other of decoration about it." But the decoration should have a use and a meaning. Beauty, Morris wrote, came when the decoration was in accord with the object and nature; ugliness, when it was in discord.[8] He apotheosized nature and tradition, the local and the vernacular, recognizing that within these elements lay a great sophistication that could lead to a new art for the age.

Morris' designs and his writings provided the primary inspiration for the international Arts & Crafts Movement and its many manifestations in different countries. Modified by local conditions and also nationalistic concerns, the Arts & Crafts had various names: Free Style in London, Art Nouveau in Brussels, Paris, and Nancy; the Style Floreale or Liberty Style in Milan and Turin; the Secession in Vienna; the Jugendstil in Munich and Berlin; and National Romanticism in Stockholm, Helsinki, and Copenhagen. Though differing in individual forms of expression, these movements are all part of the same family tree.

Much has been made of Morris' antipathy to the machine and his personal role in the revival of handicrafts. On one level, he romanticized the Middle Ages, admiring Gothic architecture and art for what he identified as its communal spirit. But Morris was a practical as well as a visionary reformer. He recognized that the machine could never be banished from life, that machine production could be beneficial because it took away much of the drudgery of repetitious tasks. The problem was modern capitalist civilization and how it used the machine. For Morris a paradox existed: could art reform life and culture, or was a political revolution necessary? How radical should this revolution be? His utopian novel *News from Nowhere* (1891) prophesies a peaceful revolt. He wavered, betwixt and between, supporting organizations such as the Arts & Crafts Exhibition Society (founded in 1887), which showed the products of artists and artisans, and at the same time arguing in a Marxian vein that political revolution must come first; only through political change could the arts regain a rightful, central place in society.

Morris' political stance provided inspiration for the American Arts & Crafts, though few Americans ever went as far left as Morris. A mild form of lowercase socialism found a couple of converts; Stickley played with it briefly before losing interest. But a political stance is present with nearly all of the Americans: Henry George's ideal of a single tax on land value found some adherents, and the word "democracy" appears countless times in the writings of Sullivan, Price, Stickley, Wright, and others. Admittedly, "democracy" had multiple meanings and became fuzzy as a concept; yet for most it meant an art available to all. But far more important than specific political words or labels was the realization that all art reflects politics in some manner and that art should have an ethical position: art was not neutral or value free. This led almost inevitably to the notion that American art should reflect an honesty, a rightness of form, a truth. The replaying of foreign styles was condemned, because in their original

incarnations they represented political systems at extreme variance with America—decadence, feudalism, monarchy, and even barbarism. Frank Lloyd Wright wanted an art that had a "spiritual integrity" with its environment. His work, and that of many others, is based on what he called "the elemental law and order" of nature, on the organic, and on practicality.[9]

In America, as in other countries, the ideal of the Arts & Crafts attracted "free spirits." The name "free spirit" carries a negative connotation, implying for today an airy-headed lack of responsibility; the terms "innovative," "adventurous," or "individualistic" contain more positive resonances. Certainly there were American Arts & Crafters with unconventional behavior, at least when measured by the norms of middle-class society, *Saturday Evening Post* conformity, and obsequious bows to "good taste." The nineteenth-century revolution in the behavior of artists, which had started in Paris with bohemian living and been expanded by English aesthetes like Oscar Wilde, found an audience in America. Elbert Hubbard and Frank Lloyd Wright affected long hair, huge flowing bow ties, and porkpie hats. Bernard Maybeck and George Harris designed their own clothing, with artists smocks and sashes. But more than fashion was at stake. These designers, architects, and craftsmen were in a sense rebels, willing to question the smug assumptions of what defined art. Many of the American Arts & Crafters (and some foreigners such as Ashbee) admired the poetry of Walt Whitman; in a sense, he was the poet laureate of the Arts & Crafts even though he died in 1892. Whitman's free, flowing verse, his sense of the necessity of a new poetic form that defied the prosy conventions of genteel, overly refined poetry, appealed to many of the artists. Whitman seemed to speak directly to the concerns of a new art when he wrote in 1881:

> When the materials are all prepared and ready, the
> architects shall appear....
> The greatest among them shall be he who best knows you,
> and encloses all and is faithful to all.[10]

The Arts & Crafts attracted those who were willing to step out of the mainstream and experience a life that dealt with essences. One finds in the Arts & Crafts two seemingly conflicting religious sentiments: the intensified ritualism of those who revived the liturgy of the Anglo-Catholic church, and the pantheism, spiritualism, and mysticism of those who rejected traditional religion for Christian Science, Unitarianism or Universalism, or more extreme forms. Some of the greatest displays of design and craftsmanship can be found in high Episcopal churches on the one hand and Unitarian and Chris-

Frank Lloyd Wright in Spring Green, Wisconsin, 1924. Reproduced in Hanks, *The Decorative Designs of Frank Lloyd Wright*, p. x

Charles Sumner Greene and Henry Mather Greene, late 1940s. Reproduced in Makinson, *Greene & Greene: Architecture as a Fine Art,* p. 265

Gustav Stickley, about 1910. Reproduced in Cathers, *Stickley Craftsman Furniture Catalogs,* p. 2

tian Science churches on the other. What unites these two ends of the spectrum is just that—the extremes and the willingness to look anew at life and its connections with the cosmos. Run down the line of the great American Arts & Crafts designers: Charles Sumner Greene, Claude Bragdon, Ellis, Wright, Stickley, Tiffany, and Dow; you will find an interest in exotic forms of religion and a concern with the spirituality of the object. With most of the Arts & Crafts designers there is a sense of some metaphysics, a recognition that the material or physical world is but one level of reality. How to accomplish the transcendence to a higher reality varied, ranging from nature to Christian mysticism, Swedenborgianism, and Theosophy. And assisting would be objects, whether a Roycroft vase or Harvey Ellis chair, that through their physicality and imagery would induce the participant to contemplate the essences of form and nature and the order of the world.

Although unconventional, and with an air of rebellion, the Arts & Crafts designers had, paradoxically, a profoundly middle-class ethos about certain elements of life. Iconographically, they concentrate on the family and shelter. The houses exist as individual units, set upon their own plot of ground. Doors are big and solid, roofs and eaves are prominent. The fireplace surrounded by snug inglenooks dominates the interior, symbolizing warmth (though it is not the primary source of heat) and the family gathered at the hearth. The greatest concentration of design energy normally appears in the dining room, where the table and high-backed chairs create a smaller, intimate space. The tables are draped as if with altar cloths, so that the entire setting looks like the holiest of rituals, a sacramental event.

The credo of the Arts & Crafts Movement called for diversity; art should be individual and reflect both its maker and location. One method was regionalism: instead of attempting to create a homogeneous style applicable to all locations, as did the American Renaissance artists and designers, the Arts & Crafters were to reflect their own regions: the flat prairies of the Midwest, the indigenous Spanish Mission culture of the Southwest, the Dutch and early English character of the East Coast. A new art would result, one reflective of local history and tradition. And how that history and tradition was read and interpreted led to the desired diversity.

In southern California, within a few miles of each other, were the Arts & Crafts masters Irving Gill and Charles Sumner and Henry Mather Greene. The Greenes drew upon the strong Oriental influence of the Pacific rim, using cloud-lift joints, *irimoya* tile roofs, and jutting rafters. Their chairs, such

as for the Tichenor house (cat. 71), are extremely Chinese in outline. They also appropriated the form of the vernacular Mexican ranch house, transforming it into bungalows with patios. Irving Gill, by contrast, perceived the Spanish heritage of California as a Mediterranean culture. Where the brothers Greene became complicated and indeed at times fussy, Gill strove for extreme simplicity, for broad, plain surfaces, which he described as "the simple cube house with creamy walls, sheer and plain rising boldly into the sky, unrelieved by cornices or overhang of roof, unornamented save for the vines that soften a line or creepers that wreathe a pillar of flowers."[11] This bucolic notion of California as a Mediterranean arcadia, a virtual Garden of Eden where man, woman, and nature exist in a symbiotic unity, can equally be seen in the work of the Bay Area artists Arthur and Lucia Mathews (cat. 88). The figures in their work stand, lie, dance, and pose within a verdant garden, a landscape of peace, beauty, and harmony.

In addition to regionalism and traditions, an American art that reflected diversity meant some reference to foreign cultures, however paradoxical this may seem. The Shop of the Crafters in Cincinnati, the brothers Greene, Dow, and others unmistakably looked abroad; they were not provincials hiding at home, knowing only their own culture. The graphic designs of Dard Hunter and Will Bradley, with their flat areas of color, simplified outlines, and stylized forms, reflect knowledge of Paris and Vienna. George Neidecken trained both in Milwaukee and Chicago and then abroad in Germany and Paris. He built some of Frank Lloyd Wright's furniture and interiors, but on his own he designed in many styles, from early English to Viennese Secession. In the Bresler Art Gallery interior (cat. 63), he synthesized the Secession, German Jugendstil, and Parisian Art Nouveau. This sophisticated decor was intended to show Japanese prints and European *objets d'art*. Neidecken's wide range of styles is endemically American, but what is typically Arts & Crafts is the avoidance of the academic, the overly historical, and the classical.

The role of international influence can be seen in the evolution of the plain and simple oak chair that goes under the generic name of Mission. All of the major designers and companies—Wright, Stickley and his brothers, Limbert, Roycroft, the Crafters and others—made variations on the Mission chair. Yet Stickley, for instance, never used the name Mission, preferring his own marketing label, Craftsman. He claimed that his simplified chairs were based on the work of American Shakers and pioneers and described them as "founded on a

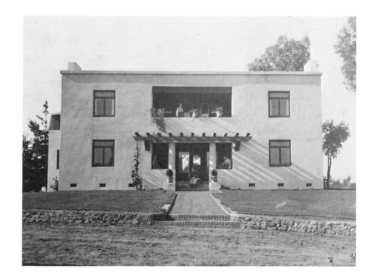

Irving Gill. *Russell C. Allen Residence*, Bonita, California, 1907. Courtesy, The San Diego Historical Society, California

return to the sturdy and primitive forms that were meant for usefulness alone." Their lack of ornament and extreme simplicity was American, reflective he claimed, of the lack of aristocracy and monarchs.[12] But Stickley, at least partially, rationalized his sources after the fact, and it is here that the international connection becomes clear. Evidence exists that he drew on other furniture manufacturers, such as Joseph McHugh of New York, who had created a chair in what he thought was the spirit of the California Missions. Actually McHugh had marketed a chair he had made for a San Francisco Swedenborgian church designed by Bernard Maybeck and A.C. Schweinfurth. Almost simultaneously a Chicago furniture manufacture, Tobey and Company, marketed a line of similar chairs. Tobey also handled Stickley's work briefly; one of the earliest Tobey advertisements for Stickley furniture claimed that the *"angular, plain and severe"* style was inspired by Morris, Glasgow, and the French Art Nouveau school at Nancy.[13] The Morris reference is probably the most accurate: beginning in the 1860s, Morris had produced a line of plain and simple, though stained, "Artisan" furniture designed by Ford Madox Brown. An even more direct source for Stickley's furniture, though never acknowledged, was the English Arts & Crafts furniture by A.H. Mackmurdo, composed of severe, simple wood forms, elaborated at their extremities and not painted. But the American designers preferred the term "Mission style" with its rhetorical flourish and native character. The name invoked the early California Missions and implied a moralistic stance of duty and purpose.

In this claim for primitive sources a certain paradox should be noted. First, the furniture was seldom crude, the only exceptions being the purposely rough Adirondack camp furniture. To be sure, there are differences in quality among the makers; Stickley's designs are in general far superior to those of the Roycrofters and The Shop of the Crafters. But no matter whose furniture is considered, most of it shows tremendous sophistication in its proportions and is responsive to advanced design theories. In making the claim for primitive sources, whether American Shaker or Mission, there was certainly a nationalistic tinge along with a certain "machismo." Stickley maintained that growing up as a "farmer boy"—in other words the simple life—led him to his honest and direct furniture.[14] And Wright made similar contentions. But those to whom the "primitive" most appealed were the sophisticated who understood the new art currents that the furniture reflected. Appreciation of simplicity requires sophistication; to reject the over-ornate, overstuffed emblems of "Bozart" good

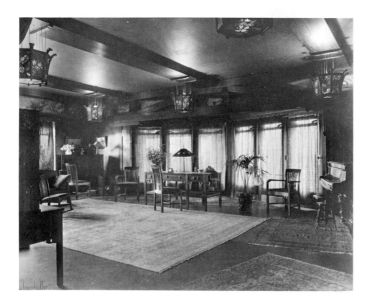

Charles Sumner Greene and Henry Mather Greene, *Living Room Interior*, Blacker house, 1907–09

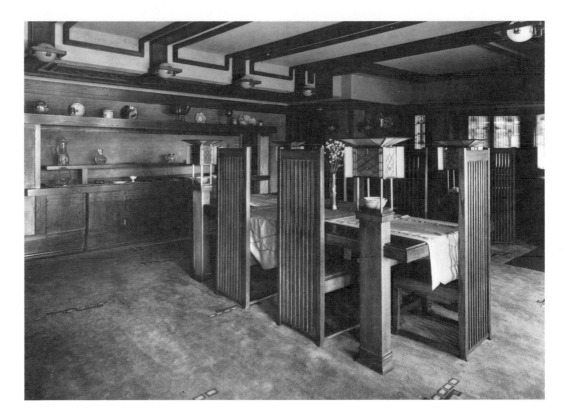

Frank Lloyd Wright. *Dining Room Interior*,
Frederick C. Robie house, Chicago, 1908.
Courtesy, Domino Center for Architecture and
Design, Ann Arbor, Michigan

taste require prior knowledge. There is about the Arts &
Crafts a certain amount of snobbish simplicity or self-con-
scious unpretentiousness.

An issue arises concerning Arts & Crafts reform. The
movement wanted to reform life, to clean up the American
home. It developed simultaneously with large-scale shifts in
American living standards and housing. It accompanied the
growth of suburbs and the ownership of single-family houses
by many Americans, and was perpetuated by the need to fur-
nish those homes. The farm and small town were no longer
the center of America, though certainly they remained as an
ethos. Their values, however, would soon be scathingly
indicted by authors like Hamlin Garland, Sherwood Ander-
son, and Sinclair Lewis. The new values of the city and suburb
were those of consumption and display, at a far remove from

the supposed simplicity of the country. Thorstein Veblen effec-
tively summed up the new values as "conspicuous consump-
tion." The members of the Arts & Crafts Movement were
caught in between, trying to claim a basis in the plain simplic-
ity of the small town and country, and yet faced with the
increasingly accepted standards of American consumption.

One can be cynical about the overall effect of the Arts &
Crafts Movement, for in a sense only those who could afford
the costly wares could indulge in their own "conspicuous sim-
plicity." In most cases, the houses of Wright, Greene and
Greene, and Maher were far beyond the pocketbook of the
average American. Stickley was relatively expensive: a side
chair of his cost $10 in 1910, while a mass-produced chair
could be purchased for under a dollar. Grueby pots, Van Erp
copperware, or Dow woodcuts were expensive frills for the

average American. Moreover, despite the rhetoric of totality, there were few total Arts & Crafts environments like the one the Greenes created for the Gambles in Pasadena, or as pictured in Stickley's magazine and books.

Though most middle-class Americans never had a total Arts & Crafts house, they did experience the work in a variety of ways, through illustrations in various magazines, in exhibitions, and in commercial outlets from department stores to the specialty craft shops. If the handicraft nature of the most exquisite items placed them beyond the reach of the average American, there were less expensive and mass-produced objects, from Sears and Roebuck's Morris chairs, Roseville pottery, to Henry Chapman Mercer's Moravian Tiles. Elbert Hubbard became a household name with his series of books on trips to the homes of the famous. Architects such as Wright designed a $5,000 concrete home for the *Ladies' Home Journal,* Stickley advertised bungalows that could be built for $3,000, and innumerable bungalow companies from coast to coast produced plans and also prefabricated houses that took up some of the aims of the Arts & Crafts. American art education was reformulated under Dow's leadership; instruction in shop and crafts skills along with academic subjects became a standard feature of secondary schools. And it was not necessary to have a completely furnished Arts & Crafts house to be part of the movement. A few carefully selected pieces of the less expensive, mass-produced variety could provide the middle class with an entry into this special world.

As indicated at the beginning of this essay, the Arts & Crafts Movement in America is diverse and paradoxical. A full understanding of its implications and its impact involves many different subjects, from politics to home furnishings, from literature to landscape design. In its widest application, the Arts & Crafts involved a reordering of life and thought. It might have been naive in its aspirations, but it helped to reorder the American visual landscape. Finally, one should turn back to the objects, to the great creations. Sit at one of the wonderful dining room tables by the Greenes or Wright and feel the wood, the corners, the joints, the quality. From them one can gain an appreciation of the craft and the vision which animated the movement.

RICHARD GUY WILSON

Professor of Architectural History
University of Virginia

Notes

1. The most substantial treatment can be found in Wendy Kaplan, ed., *"The Art That Is Life": The Arts & Crafts Movement in America, 1875–1920*, exh. cat. (Boston: Museum of Fine Arts, 1987); also to be noted is the pioneering work, Robert Judson Clark, ed., *The Arts & Crafts Movement in America 1876–1916*, exh. cat. (Princeton: The Art Museum, Princeton University, 1972).

2. Frederick C. Moffatt, *Arthur Wesley Dow,* exh. cat., National Collection of Fine Arts (Washington, D.C.: Smithsonian Institution Press, 1977), p. 78; Frank Lloyd Wright, "In the Cause of Architecture" (1908), reprinted in *Frank Lloyd Wright on Architecture,* ed. F. Gutheim (New York: Grosset and Dunlap, 1941), p. 34.

3. Frank Lloyd Wright, "The Art and Craft of the Machine " (1901), reprinted in *Frank Lloyd Wright: Writings and Buildings,* eds. E. Kaufmann and B. Raeburn (New York: Meridian, 1960), p. 58.

4. Arthur W. Dow, *Composition,* 6th ed. (New York: Baker & Taylor Company, 1905), pp. 6, 80, 76.

5. See Richard Guy Wilson, Dianne H. Pilgrim, and Richard N. Murray, *The American Renaissance, 1876–1917,* exh. cat. (New York: The Brooklyn Museum, 1979).

6. Wright, "The Art and Craft of the Machine," p. 56.

7. Ibid.

8. Wiliam Morris, "Innate Socialism," also known as "The Decorative Arts" (1878), reprinted in *William Morris: Selected Writings and Design,* ed. A. Briggs (Harmondsworth, England: Penguin Books, 1962), pp. 84–85. There is extensive literature on Morris; the best is Peter Stansky, *Redesigning the World: William Morris, the 1880s, and the Arts and Crafts* (Princeton: Princeton University Press, 1985).

9. Wright, "In the Cause of Architecture," pp. 35, 31.

10. Walt Whitman, "Song of the Rolling Earth" (1856, 1881), in *Leaves of Grass and Selected Prose,* ed. S. Bradley (New York: Holt, Rinehart and Winston, 1949), p. 190.

11. Irving J. Gill, "The Home of the Future: The New Architecture of the West: Small Homes for a Great Country," *The Craftsman,* 30 (May 1916), p. 150.

12. Gustav Stickley, in *Chips from the Craftsman Workshops* (1906), quoted in Mary Ann Smith, *Gustav Stickley: The Craftsman* (Syracuse: Syracuse University Press, 1983), p. 3; and "An Outline of Furniture-Making in This Country," in Stickley, *Craftsman Homes* (New York: Craftsman Publishing Company, 1909), p. 156.

13. An advertisement for the Tobey Furniture Company for October 7, 1900, in *The Chicago Tribune* is reproduced in David M. Cathers, *Furniture of the American Arts and Crafts Movement* (New York: The New American Library, 1981), p. 37.

14. *Catalogue of Craftsman Furniture Made by Gustav Stickley at the Craftsman Workshops Eastwood, N.Y.* (Syracuse: Craftsman Publishing Company, 1909), p. 3.

The East Coast

In June 1897, the Boston Society of Arts and Crafts held its first meeting, and within the next decade scores of similar groups had formed throughout the United States, spreading the gospel of the Arts & Crafts Movement. In Europe, and especially in Great Britain, the utopian reformist ideals of Thomas Carlyle, John Ruskin, and William Morris had provided a philosophical framework for the movement. These thinkers greatly influenced many of the first Arts & Crafters in the United States, such as Gustav Stickley and Elbert Hubbard. In the early years of this century, they began to spawn workshops for the manufacture of furniture, ceramics, metalwork, and other decorative wares. In the dissemination of Arts & Crafts philosophy, the East Coast quickly became an important center for the new craftsmanship.

Elbert Hubbard had met William Morris in 1894. Inspired by Morris' Kelmscott Press, he founded the Roycroft Press, near Buffalo, the following year. Gustav Stickley was first introduced to Arts & Crafts principles through the writings of John Ruskin as well as Morris. He made his pilgrimage to England in 1898, where he saw the influential designs of the architects C.R. Ashbee and Charles F.A. Voysey. Upon his return to America later that year, he established the United Crafts in Eastwood, New York, and began publication of his seminal journal, *The Craftsman*, in 1901. Like Morris, Stickley organized his workshop on the precepts of the medieval guild, borrowing from Morris the Flemish motto, "Als ik kan" ("As best I can")—which he used for his shopmark. The attention paid by Morris and Ruskin to the skilled artisan, and their insistence on quality craftsmanship, simplicity of design, and truth to the nature of materials, stayed with Stickley throughout his career. His furniture designs, with their emphasis on workmanship, functionalism, and a frank expression of the structure underlying each piece, epitomize the best of the Arts & Crafts Movement in America.

Born in Wisconsin, Stickley was trained by his father as a stonemason; as a young man he worked with his brothers in his uncle's chair factory in Pennsylvania. The Stickley brothers —Gustav, Charles, Albert, Leopold and John George—all devoted themselves to making furniture, and over the years several separate companies were established for the manufacture of what became known as Craftsman or Mission furniture. In the 1880s, Charles, Albert, and Gustav started the first company, Stickley Brothers, in Binghamton, New York, at first selling popular furniture and, later, pieces of their own design and manufacture. Albert and John George established the Stickley Brothers Furniture Company in Grand Rapids,

Gustav Stickley
Work Cabinet (detail). CAT. 14

Michigan, in 1891; in 1902 John George left the firm to open the Onondaga Shops with Leopold in Fayetteville, New York. Gustav, who had started his Craftsman line several years before, now found himself in competition with his younger brothers. Leopold and John George were astute businessmen and outstanding furniture makers, and though many of their designs were borrowed from Gustav, their success is reflected in the rapid expansion of the business, incorporated in 1904 under the name L. & J.G. Stickley, Inc. It is still in operation today.

Gustav Stickley's empire also grew quickly in the early years of the century. He sponsored franchises from Los Angeles to Boston, and in 1913 purchased a large building in Manhattan where he opened showrooms, offices, and a restaurant. But the move proved overly ambitious: two years later he was forced to declare bankruptcy. The advent of modernism, and with it the change in public taste, had brought the popularity of Stickley's design ideals to an end. Ironically, today Stickley is regarded as a central figure in the development of modern design. Though his lifelong concern for craftmanship, solid construction, and truth to materials ties him to Arts & Crafts design of the nineteenth century, his emphasis on functionalism and purity of form anticipate the International Style of the 1920s and make him, in the words of David Cathers, "a pioneer perhaps more than any other Arts and Crafts designer of what this century has come to consider modern design" (Cathers 1981, pp. 55-56).

Elbert Hubbard brought his genius for mass-marketing—perfected in his highly successful business career with the Larkin Company—to the Arts & Crafts philosophy he adopted from William Morris. An enthusiastic promoter, he founded a group of enterprises, in addition to the Roycroft Press, which produced furniture, books and bindings, leatherwork, and metalware. The Roycroft Community's more than four hundred members, known as Roycrofters, lived and worked on the property, modeling themselves on the utopian communities of the British Arts & Crafts Movement. The Roycrofters nonetheless had a decidedly commercial slant. The Roycroft Inn, for example, was designed to accommodate the many tourists who had learned of the Roycroft Community through its mail-order catalogues or its publications (the *Little Journeys* pamphlets and *The Philistine* monthly) and to provide the community with an outlet for Arts & Crafts gift items and souvenirs.

The Arts & Crafts Movement in the East was also represented by Charles Rohlfs, one of its more eccentric practition-

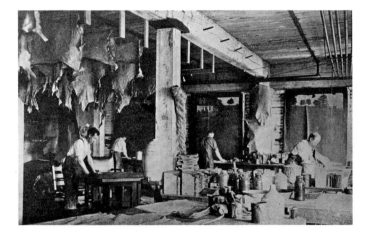

Leather Workers (Gustav Stickley's Workshops of the United Crafts, Eastwood, New York). Reproduced in *The Craftsman*, 3 (October 1902), opp. p. 61

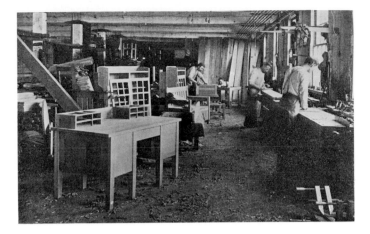

Joiners (Gustav Stickley's Workshops of the
United Crafts, Eastwood, New York). Repro-
duced in *The Craftsman*, 3 (October 1902),
opp. p. 60

ers. He established his own workshop in Buffalo in 1898, and
soon was making entire rooms of furniture for wealthy clients
throughout the United States. His designs incorporate medie-
val and even Moorish motifs, which give his elaborately
carved and articulated pieces a distinctly Gothic look. Yet the
relatively simple construction of his furniture and Rohlfs'
respect for his materials align him with the Arts & Crafts
Movement, in which "he was one of the few American...fig-
ures to produce a convincingly personal version of the Art
Nouveau" (Boston 1987, p. 94).

Any discussion of the Arts & Crafts Movement on the east-
ern seaboard must necessarily include Louis Comfort Tiffany,
whose work in pottery, and especially in stained and art glass,
was affordable to much of the middle class and became
immensely popular. Although his style was based more on the
Art Nouveau aesthetic, his works were at home in the Arts &
Crafts environment. In an object such as the lamp (cat. 30)
that combines a Grueby base and a Tiffany shade, the happy
marriage of these two styles is evident.

The matte green pottery glaze that became the trademark
of the Grueby pottery companies was perfectly suited to the
Arts & Crafts interior, and for many collectors a piece of
Grueby pottery was an essential object. Certainly the preemi-
nent pottery manufacturer on the East Coast, William Grueby
and his designers, George P. Kendrick and later Addison
LeBoutillier, won many awards for their work at international
expositions, often exhibiting their ceramics together with the
furniture of Gustav Stickley.

Besides Grueby, the East Coast boasted other important
pottery makers, including Chelsea Keramic Art Works (later
Dedham Pottery) in Dedham, Massachusetts, whose founders,
the Robertson family, had been producing art pottery as early
as 1872. The Marblehead Pottery, Marblehead, Massachu-
setts, established in 1904, produced ceramics with muted,
matte glazes, often with incised and painted decorations. And
Fulper Pottery, in Flemington, New Jersey, the oldest pottery
in the country, broke into the market with its Vase-Kraft line
in 1910, which included a wide range of glazes.

The extensive Arts & Crafts activity on the East Coast was
reflected in the periodicals published there, which conveyed to
the national public the principles of Arts & Crafts philosophy
and design. Without Gustav Stickley's *The Craftsman*, Elbert
Hubbard's *The Philistine* and *Little Journeys*, and Adelaide
Alsop Robineau's *Keramic Studio*, the popularization of the
Arts & Crafts style would have been much diminished, and
the movement itself might have been even more short-lived.

As it was, the change in popular taste around World War I
to a more traditional and less severe style brought the curtain
down on this country's first exposure to modernist design. But
the fundamental Arts & Crafts principle of integrating art and
design into the domestic environment and the movement's leg-
acy of good design for the average householder remain with us
today.

ANN YAFFE PHILLIPS

Charles Rohlfs

1853–1936

I.

Desk and Chair, about 1900

Charles Rohlfs

Desk: oak, with green stain and metal,
72 x 57 x 36

Chair: oak, with green stain and leather
upholstery, 36 x 29 x 22

RECORDED: Volpe and Cathers 1988,
pp. 42, 43 illus. in color, 44–49

Rohlfs' earliest involvement with furniture
making was generated by self-interest and
necessity. Working out of an attic studio
in Buffalo during the 1880s, he produced
furniture primarily for himself and a few
close friends and neighbors (Boston 1987,
pp. 237, 240–42). But as more and more
people became aware of his work, his list
of clients grew to include Marshall Field
of Chicago as well as other wealthy indi-
viduals in Buffalo, New York City, Phila-
delphia, Paris, London, and Bremen. By
1898 Rohlfs had moved his workshop
into a larger commercial space in down-
town Buffalo, and after several successful
showings at the Pan-American Exposition

in 1901, the Turin Exposition in 1902,
and the Louisiana Purchase Exposition in
1904, his work was eagerly sought after.

Like other American Arts & Crafts furni-
ture designers, Rohlfs acknowledged a
variety of styles—medieval, Moorish,
early Norwegian, and Art Nouveau—
which he appropriated and revamped
according to his own taste and use. He
was not averse to incorporating intricate
carving and embellished surfaces as a
means of distinguishing his work from
Stickley's austere and reductive Mission
furniture. This desk and chair, for
instance, have the swell and proportion of
something medieval. Two rear posts on
the desk support a gallery of twelve
drawers and lower pigeonholes. The body
of the desk, supported by twin pedestal
feet, contains more drawers and a knee-
hole with a frieze drawer. The swivel chair
has a pierced back flanked by scrolled
supports and flat armrests; it has four
curved feet and is upholstered with a
strapped leather cushioned back and seat.
Both the desk and chair are deeply carved
and ornamented.

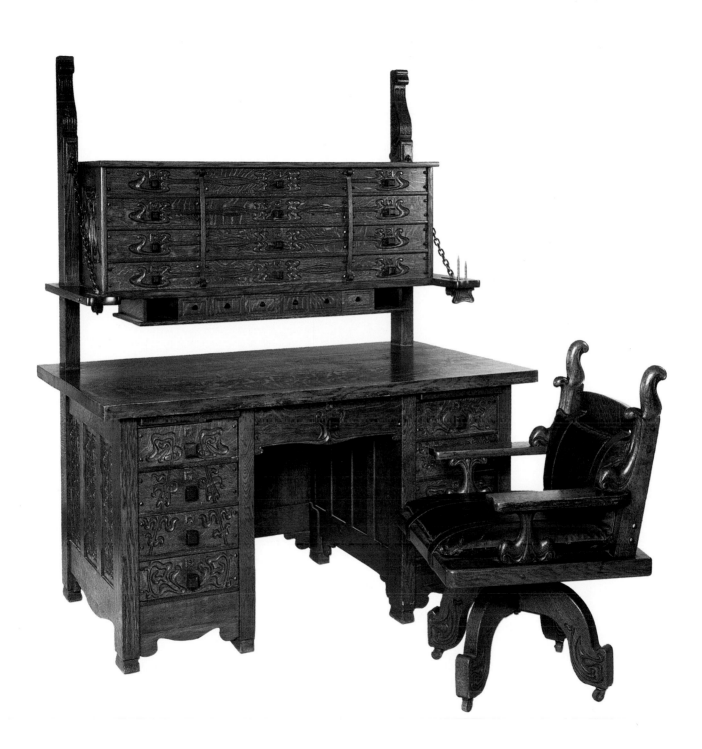

Roycroft

1895–1938

2.

Pair of Candlesticks, about 1915–20

Roycroft

Hammered copper, 11 3/4 high
Marked (on strap under drip pan, with
Roycroft logo)

In 1905, Elbert Hubbard expanded his
production of Arts & Crafts objects to
include metalware.

This new enterprise flourished after 1909,
when Karl Kipp, a former banker, was
hired by Hubbard to set up an art copper
department. Kipp was much influenced by
Vienna Secessionist design.

This pair of candlesticks, composed of
four vertical copper straps joined at vari-
ous points by decorative structural ele-
ments, and wide drip pans with heavy
planishing, combines medieval characteris-
tics with a modern approach toward
direct and honest construction.

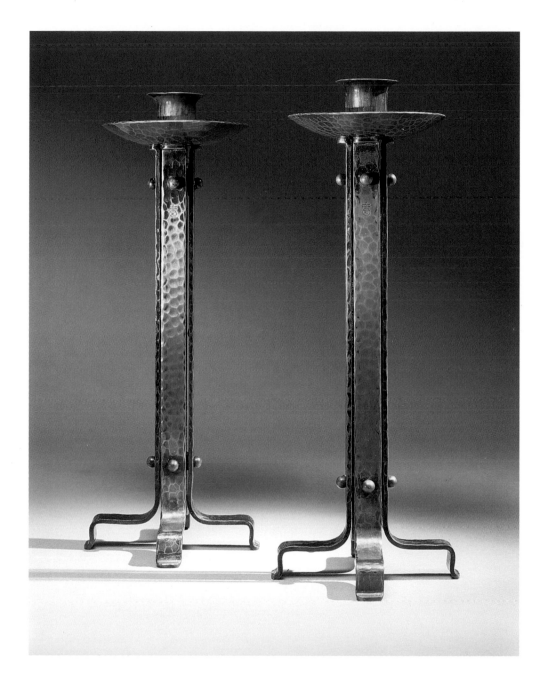

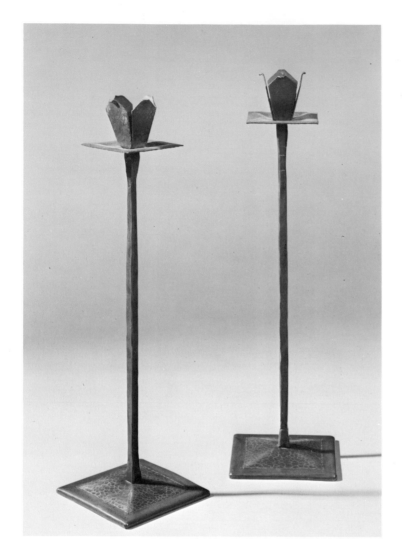

3.

Pair of Candlesticks, about 1912

Roycroft

Hammered copper, 14¹/₂ high
Marked (underneath, with Roycroft logo)

RECORDED: Gray 1989, p. 29 illus. a similar example

These tulip candlesticks with their rough, hand-hewn quality, and their open, petal-formed candle cups, seem to derive from Stickley's more forthright designs for copperware. They were probably made during the brief period when Kipp left Roycroft to found the Tookay Shop for the production of metalware of his own design. He returned to Roycroft in 1915, after the death of Hubbard and his wife, and his designs were in production into the 1930s.

Gustav Stickley

1858–1942

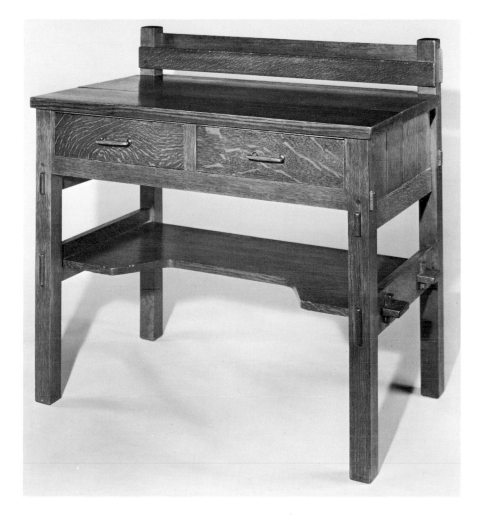

4.

Desk, about 1901

Gustav Stickley

Oak, 34¹/₂ x 34¹/₄ x 20¹/₈

Marked with red decal (on the back rail of letter rack): Als/ik/kan/Stickley

RECORDED: Gray and Edwards 1981, p. 24 illus. an identical example

Given its compact scale and utilitarian design, this desk was probably intended as a woman's writing table. Within a typical Craftsman house it would have been placed in either the bedroom or the sitting room. It is Gustav Stickley's original version, which he published, with wrought-iron pulls and a sage-green leather top, in *The Craftsman* (November 1901). The desk was copied later by L. & J.G. Stickley (Gray and Trapp 1983b, pp. 26 no. 401, 67 no. 401, 124 no. 601), who altered its basic design and detailing, varying proportions, joinery, and hardware.

Sideboard, about 1902

Gustav Stickley

Oak, with iron hinges, pulls, and escutcheons, 43 x 60 x 24
Marked with red decal (on back splash): Als/ik/kan/Stickley

RECORDED: Gray 1987, p. 111 no. 967 illus. a smaller example

By 1900 Stickley had developed his own designs, which reflected an indigenous American Arts & Crafts philosophy. His work of this period displayed overt structural details such as tenon-and-key construction, chamfered boards, and exposed tenons. The curved lines that characterized some of his earlier experimental pieces gave way to rectilinear shapes and plainer, more straightforward design. These massive pieces were free of any excess ornamentation except for what naturally occurred in the construction, design, and material. By making such construction elements as tenon-and-key joints visible, and by accentuating the natural grain of the wood, Stickley revealed not only the excellent craftsmanship that went into each piece, but also the beauty, simplicity, and utility of the design.

This sideboard has several characteristics of what David Cathers (1981, pp. 38–39) has termed Stickley's "First Mission Period," from 1900 to 1904. The only ornamentation is in the structural details, such as the exposed tenons on the sides and the chamfered boards used for the cabinet doors. According to Cathers (p. 203), the distinctive square-faceted pulls and butterfly-shaped plates are found only on pieces made between 1901 and 1903.

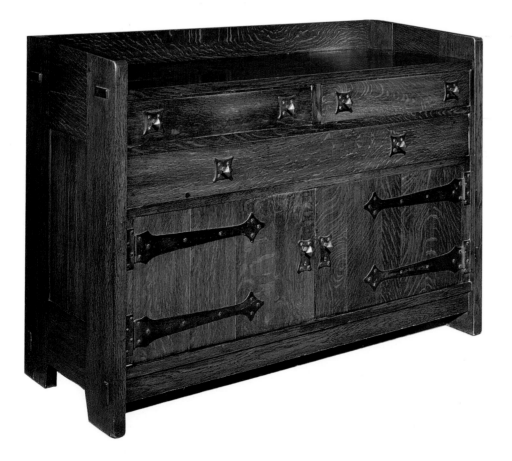

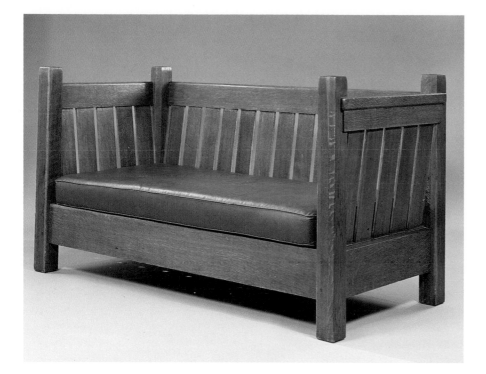

6.

Crib Settle, about 1902

Gustav Stickley

Oak, 39 x 70 x 30
Marked with red decal (on back crest rail): Als/ik/kan/Stickley

RECORDED: Gray and Trapp 1987, p. 74 no. 173 illus. an identical example

EX COLL.: the artist's workshop; to Senator Nelson Aldrich, Edgartown, Massachusetts, 1902–29; to The Edgartown Reading Room, Massachusetts, 1929–89

This form is arguably one of the most complicated of Stickley's settle designs. In Stickley's 1901 *Chips from the Craftsman Workshops* catalogue, it is referred to as a bungalow settle, perhaps indicating Stickley's feeling that it was entirely at home in the bungalows so common during this period. It is also the first large-scale true settle that Stickley designed; other forms at this same time were either love seats or hall benches.

A number of subtle design details found in this settle belie the artist's claims that his furniture was simple and straightforward. Perhaps the most notable feature is the canting sides and back, which give the piece a greater degree of comfort while helping to define the volume of its interior. The side crest rails are articulated with a shaped nosing that overlaps the wide post in front and back. This overlap is highlighted with a flush dowel, structurally unecessary, but serving as a fine detail of construction. The tops of the lower rails are also shaped on the sides and back, again visually enlivening what would otherwise have been a broad, flat plane.

The settle is one of a pair purchased in 1902 for a boat house on Martha's Vineyard that belonged to the then-senator from Rhode Island, Nelson Aldrich. Both settles remained at this location—converted to a men's club called The Edgartown Reading Room in the 1930s—until 1989.

7.

High-Back Settle, about 1902

Gustav Stickley

Oak, 65^3/$_4$ x 57 x 20^1/$_8$
Marked with red decal (on back, top center): Als/ik/kan/Stickley

RECORDED: Gray and Edwards 1981, p. 38 illus. an identical example

EXHIBITED: Boston 1987, pp. 382–83 no. 204, lent by Mr. and Mrs. John M. Angelo

EX COLL.: Mr. and Mrs. John M. Angelo; to (sale, Christie's, New York, June 11, 1988, no. 39); to (Hirschl & Adler Galleries, New York); to (Struve Gallery, Chicago); to private collection, Chicago

Private Collection

This settle was made for the front hall of Gustav Stickley's home in Syracuse. Since it does not appear in any of the Craftsman furniture catalogues, it was probably a custom design. A similar settle is illustrated in *The Craftsman* (May 1903; Gray and Edwards 1981, p. 38). The two settles differ largely in the pattern of butterfly splines across the seat backs. Stickley used the butterfly spline from time to time on various pieces, from screens to cabinets (Gray and Edwards 1981, p. 28, and Cathers 1981, p. 242). Stickley considered the raised butterfly spline a fundamental element of construction and, as with the through-tenon, he made no attempt to mask its appearance. The result here is a quite beautiful decorative effect.

The high-back settles are more elegant and imposing versions of smaller, low-back settles, such as the one illustrated in the August 1902 issue of *The Craftsman*, as "The settle in the living-room" (Gray and Edwards 1981, p. 31). These high-back versions resemble more closely a freestanding inglenook settle rather than the low-back or slatted settles available through the Craftsman Workshops.

The settle form was a variation on a Colonial model, which enjoyed a revival during the 1870s and 1880s as part of a Queen Anne inglenook and fireplace ensemble. Stickley's version differs from these earlier precedents in its use of raised butterfly splines, Gothic arches at the legs, and oak instead of pine or poplar. According to his grandson, Peter Wiles, Stickley's own home included at least one and possibly two settles besides the hall settle pictured here.

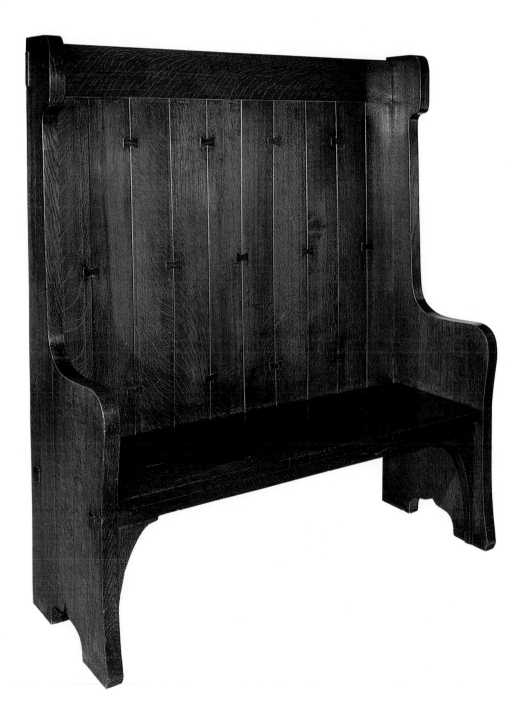

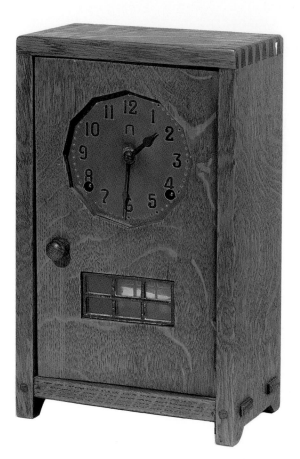

8.

Mantel Clock, about 1902–16

Gustav Stickley

Oak and brass, 13³/₄ x 8¹/₂ x 5
Marked (on the face): Als/ik/kan

Stickley began designing clocks in 1902
and, according to David Cathers (1981,
p. 248), examples of clocks by both Gus-
tav and L. & J.G. Stickley are very rare.
Typical of Stickley is the simple, well-
proportioned design, with the emphasis on
structural elements such as the exposed
tenons and butterfly keys and the natural
grain of the wood. The movement of this
clock is by Seth Thomas.

9.

Hexagonal Games Table, about 1903

Gustav Stickley

Oak and leather with brass tacks,
30³/₄ x 53 diameter
Marked with red decal (on bottom of
drawer): Als/ik/kan/Stickley

EX COLL.: private collection, Hampton,
New Hampshire, until 1989

In his concern for the total home environ-
ment, Stickley designed not only basic
furnishings, but less essential pieces, such
as pianos, pool tables, games tables, and
smaller decorative accessories.

The hexagonal shape of this table per-
fectly suits its function. Stickley's idea for
the form may have come from a hexago-
nal library table that first appeared in the
1901 *Chips from the Craftsman Work-
shops* catalogue (Cathers 1981, p. 209
illus.). This games table, however, is con-
siderably heavier in appearance due to the
sturdy, square-shaped legs, the under shelf
supported by exposed tenon cross
stretchers, and the thick top with drawers
outlined in brass tacks.

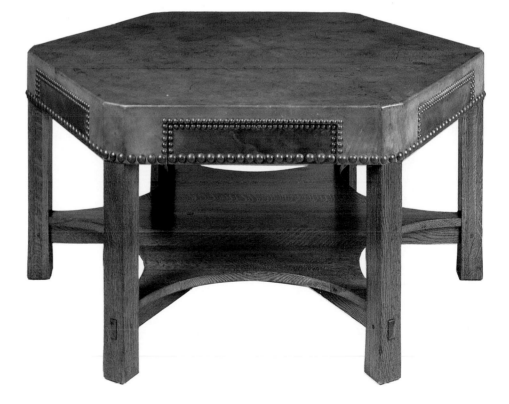

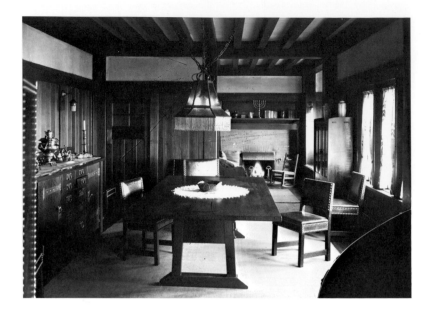

Gustav Stickley, *Dining Room*, Stickley's private residence, Syracuse, New York, about 1902–03. Courtesy, The Henry Francis du Pont Winterthur Library: Decorative Arts Photographic Collection

10.

Director's Table and Eight Dining Chairs from Stickley's Private Residence, Syracuse, New York, about 1902–03

Gustav Stickley

Table: oak, 29³/₄ x 95³/₄ x 54¹/₂
Marked with red decal (on bottom runner of table top): Als/ik/ kan/Stickley
Chairs: oak and leather; two armchairs, 36³/₄ x 26¹/₈ x 21⁵/₈, six side chairs, each about 33³/₄ x 19¹/₄ x 18¹/₂
Each marked with red decal (on inside of back leg): Als/ik/kan/ Stickley

RECORDED: Gray and Edwards 1981, pp. 13 illus. a similar example (table), 111 nos. 355, 355A illus. identical examples (chairs) // Gray 1987, p. 94 no. 935 (table) illus. a smaller example

EXHIBITED: Nabisco Brands USA Gallery, East Hanover, New Jersey, 1983, *Gustav Stickley and the Craftsman Ideal*, nos. 15, 16, 17

EX COLL.: Gustav Stickley, Syracuse, New York; to his daughter and son-in-law, Barbara and Ben Wiles; to their son, Peter Wiles, Sr., until 1988

Stickley's home at 438 Columbus Avenue, Syracuse, was gutted by a fire on Christmas Eve, 1902. This tragic event, however, inspired Stickley to completely redesign and refurnish his home at perhaps the most innovative point in his career. When the house was sold in 1911, it was with the stipulation that the furnishings and interior remain intact and that Stickley retain the option to repurchase. In 1919, Barbara and Ben Wiles bought the house, and Stickley resided there for the rest of his life.

Among the pieces of furniture that Stickley produced for his Columbus Avenue home were this director's table and set of eight accompanying chairs. He later offered similar chairs for sale in his 1904 catalogue, with the note: "A very heavy chair, adapted for use in a large room."

The director's table was inspired by a Baillie Scott design of about 1901 showing similar broad top, deep apron, and shoe-footed legs (Boston 1987, p. 84, fig. 12). In Stickley's design, the apron is joined to the legs by large exposed pins. The table was later copied by L. and J. G.

Stickley and was published in their catalogue in 1910.

Stickley produced this table in two different sizes between 1901 and 1908: 54 inches deep (offered only in his 1901 catalogue); and 48 inches deep, which he began producing in 1901. The 54-inch size was not included in any catalogues after 1901, and was most likely only available as a custom-ordered piece. For this reason the 95 x 54-inch size, of which the present table is an example, is extremely rare, and today only a few are known to exist. According to Stephen Gray, the other known tables in this size differ from this example in that the table-tops are cut at 45 degree angles, presumably for space considerations. Stickley's dining room was extremely large, allowing him to leave the corners of his own table uncut. The design of this table, therefore, may be unique in Stickley's production.

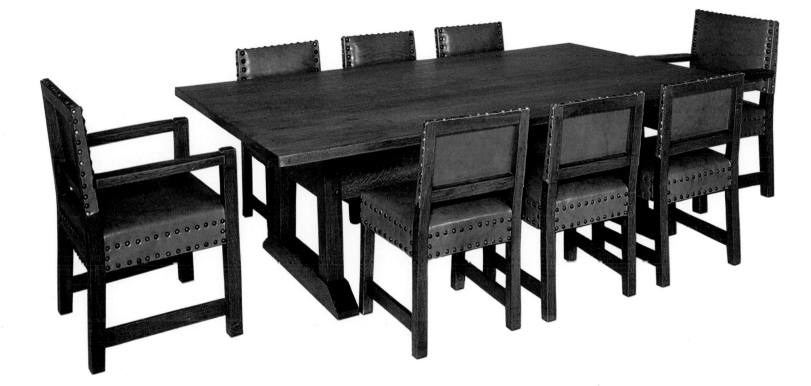

Gustav Stickley

1858–1942

Harvey Ellis

1852–1904, designer

II.

Inlaid Fall Front Desk, 1903–04

Gustav Stickely
Harvey Ellis, designer

Oak, with copper, pewter, and wood
inlay, 44 x 30¹/₄ x 12⁷/₈
Marked with red decal (on the center of
upper back panel): Als/ik/kan/Stickley

RECORDED: Gray and Edwards 1981,
p. 48

EX COLL.: probably purchased at the
Louisiana Purchase Exposition in St. Louis
in 1904; to private collection; by descent
in the family, until 1988

In 1903 an important change took place
at United Crafts when Stickley hired the
architect and designer Harvey Ellis. Ellis
had led a rather nomadic existence, work-
ing for various firms in New York and
Minnesota, and he suffered from chronic
alcoholism. Yet Stickley recognized in him
a genius for design, and shared with him
an enthusiasm for Arts & Crafts ideals.
Ellis spent the last months of his life
designing houses, furniture, and wall
decorations for Stickley's United Crafts
Workshop in Eastwood, New York.

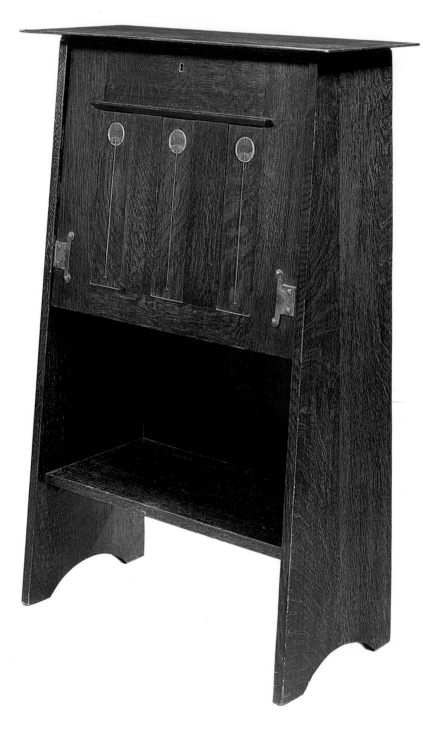

Ellis' line of inlaid furniture was first advertised in *The Craftsman* in July 1903, and prototypes appeared in the January 1904 issue just after his death. The loss of the designer and the high cost of production led to the discontinuation of this line of furniture after June 1904. Produced only for specialty and display purposes, the inlaid furniture never achieved great commercial success, although examples were exhibited, along with other Stickley furniture, at the Louisiana Purchase Exposition in St. Louis in 1904. The short production life of Ellis' inlaid pieces and their status as the last of his designs make these works extremely rare.

Ellis was influenced by the work of the British Arts & Crafts Movement, especially that of the architects M.H. Baillie Scott, C.F. Voysey, and Charles Rennie Mackintosh. The lighter and more fluid lines of his furniture designs, with their incorporation of overhanging tops, arched aprons, and inlaid elements, were a distinct departure from the more sober style of Stickley's Craftsman furniture. The abstracted floral motifs of Ellis' inlays, here in pewter, copper, and wood, were inspired by Mackintosh's designs, which appeared in art journals of the period. This desk is one of Harvey Ellis' finest and most compact designs for Stickley.

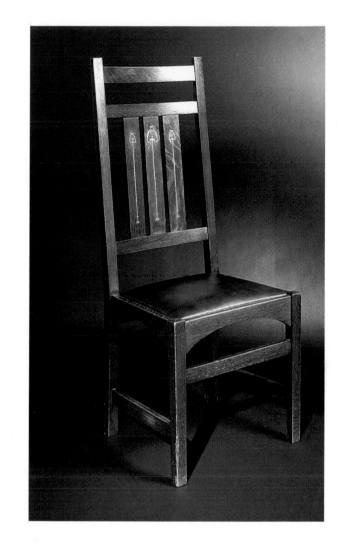

12.

Inlaid Side Chair, 1903–04

Gustav Stickley
Harvey Ellis, designer

Oak, with inlays of dark wood, copper, and pewter, 43 x 17 x 16¹/₂
Marked with red decal (on inside of rear left leg): Als/ik/kan/Stickley

RECORDED: Gray and Edwards 1981, p. 52 // Princeton 1972, p. 36 no. 37 illus. an identical example

This inlaid side chair can be dated between January and May 1904, because of the position of its leg stretcher, which was changed after May of that year. It bears also the 1902–04 decal, which was discontinued after the first months of 1904. The chair is in its original condition, except for a new seat pad, which restores a previous modification of a drop-in seat to the original padded seat design.

Double Door Bookcase, 1903–04

Gustav Stickley
Harvey Ellis, designer

Mahogany, 58 x 60 x 14
Marked with red decal (on the back):
Als/ik/kan/Gustav Stickley

RECORDED: Gray and Edwards 1981,
pp. 93 no. 703 illus., 136 illus. a similar
example // Cathers 1981, pp. 106 illus. a
similar example, 114 // Volpe and
Cathers 1988, pp. 34–35 fig. 7 illus. in
color a smaller example

This bookcase displays some typical Ellis
design elements in its wide overhanging
top, arched apron, and its lack of hard-
ware. Stickley published the bookcase in
his 1904 catalogue. It was offered in three
sizes, and available in oak, maple, or
mahogany. By 1907 it was made in oak
only, so that this mahogany version is
extremely rare. Furthermore, although
Stickley continued to produce bookcases
of this design until 1909, the use of leaded
glass at the top was phased out in 1908
or 1909, and replaced with wooden
muntins.

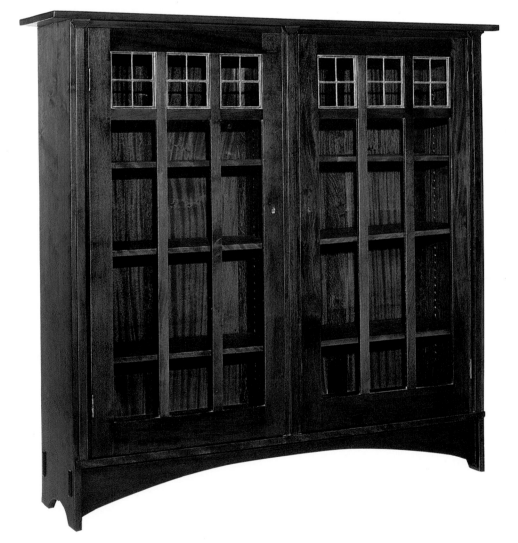

Gustav Stickley

1858–1942

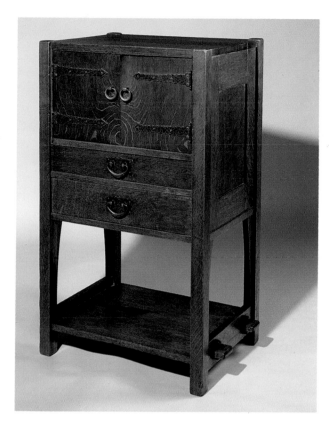

14.

Work Cabinet, about 1904

Gustav Stickley

Oak, 36 x 20¹/₂ x 15¹/₄

Marked with red decal (on bottom of second drawer): Als/ik/kan/ Gustav Stickley; Craftsman label (on bottom of second drawer)

RECORDED: Gray and Edwards 1981, p. 23 illus. a similar example

An example of this work cabinet first published in *The Craftsman* in November 1901 differs from the present piece only in the shape of its pulls. The published piece had square-faceted pulls; this one displays the flattened V-shape pulls that Stickley first used in 1904. A label in the drawer, marked "old piece," suggests that this work cabinet may have been made in 1901 and that its hardware was subsequently replaced.

15.

Box Settle, about 1904

Gustav Stickley

Oak, 29 x 76 x 32
Marked with red decal (on back bottom
stretcher): Als/ik/kan/ Gustav Stickley

RECORDED: Gray and Edwards 1981,
p. 58 no. 208 illus. an identical example

This settle appeared in Stickley's 1904
furniture catalogue and was available with
either leather or canvas upholstery. Stick-
ley's original description of the piece
reflected his continuing concern not only
with craftsmanship and design but also
with comfort. He wrote: "The back and
ends form a natural rest for arms and
head when supported by pillows. The
tenons of the side rails projecting through
back and front posts are a pleasing fea-
ture."

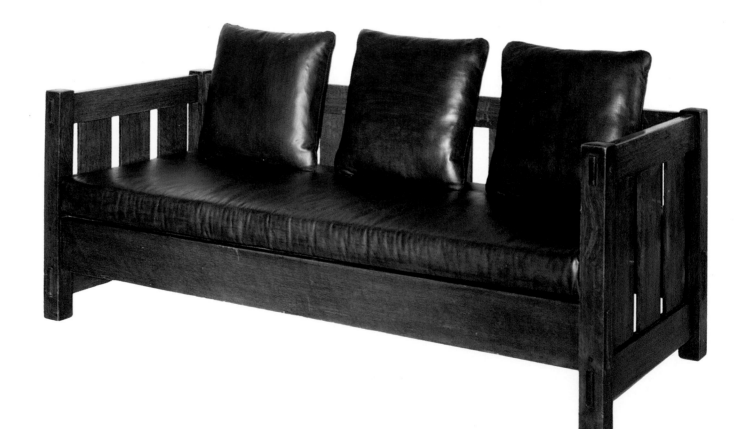

16.

Pair of Spindled High-Back Armchairs,
about 1904

Gustav Stickley

Mahogany, with leather upholstery,
each 48¹/₂ x 27¹/₂ x 20
Marked with red decal (on back
stretcher): Als/ik/kan/Gustav Stickley

RECORDED: Cathers 1981, pp. 129
illus. an identical example, 147–48

EX COLL.: St. Augustine Home, Peoria,
Illinois, 1904–88

Stickley began producing his line of spin-
dle furniture about 1904. He obtained a
patent for the design on August 8, 1905,
and this high-back armchair appeared in
The Craftsman later the same year. The
more delicate spindles replaced the wide
slats of Stickley's earlier furniture, reflect-
ing his trend toward less massive designs
following his association with Harvey
Ellis. Stickley discontinued his line of
spindle funiture about 1909. Because
these pieces were produced for such a
short period, examples of them are quite
rare.

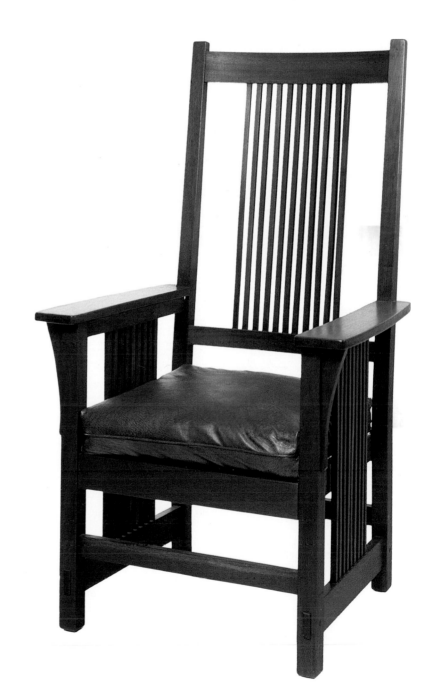

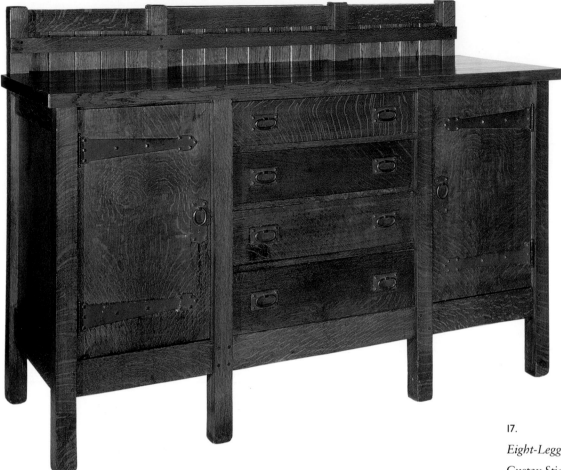

17.

Eight-Legged Sideboard, about 1904–10

Gustav Stickley

Oak, 50 x 70¹/₂ x 25¹/₂
Marked with red decal (on bottom of
second drawer):
Als/ik/kan/ Gustav Stickley

RECORDED: Cathers 1981, pp. 195
illus. a smaller example, 204

Stickley produced several variations of this
sideboard between 1901 and 1910. The
earliest design differed from this example
in having exposed tenons on the legs,
cabinet doors made of chamfered boards,
and wooden nobs on the center drawers.
The present version first appeared in *The
Craftsman* in 1904. Except for strap
hinges, which have a blunted-arrow shape
here but were rectangular in later versions,
the sideboard remained basically
unchanged until 1910.

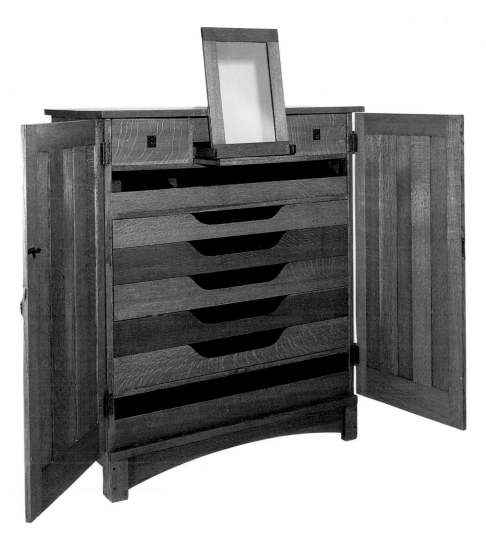

18.

Wardrobe, about 1907–12

Gustav Stickley

Oak, 54¹/₄ x 45 x 24
Marked with red decal (on bottom of top drawer): Als/ik/kan/ Gustav Stickley; Craftsman label (on the back)

EX COLL.: Arthur Cahill, San Francisco

This wardrobe was designed for Arthur Cahill of San Francisco. Its elegantly arched apron, overhanging top, and sparse use of hardware suggest the influence of Harvey Ellis, yet the exposed pins on the legs and the use of chamfered boards for the doors are typical Stickley devices. The extremely plain design accentuates the varying grains of the boards on the sides and doors.

Because it was a private commission, this wardrobe differs significantly from Stickley's standard production wardrobe as it appeared in his 1902 catalogue. The Cahill wardrobe is more horizontal in proportions, all its drawers are completely enclosed inside a double set of doors, and, in contrast to the standard production piece, which has a full-length mirror on the inside of the door, the Cahill wardrobe has a stylish pull-out shaving mirror with two small drawers on either side.

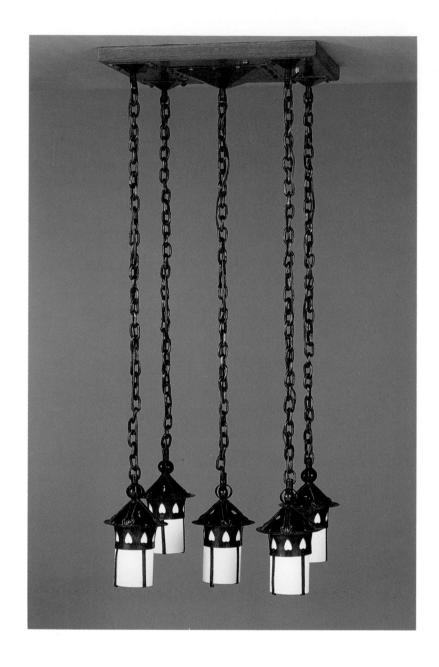

19.

Five Light Copper and Oak Chandelier from the Phair House, Presque Isle, Maine, about 1906

Gustav Stickley

Oak, copper, glass, and metal, 18 1/4 x 18 1/4

RECORDED: Gray and Edwards 1981, p. 149 no. 205 illus. an identical lantern

Charles Phair's house was designed by Craftsman architects in 1906. Phair, a member of one of the settler families of Presque Isle, was influential in the community, having made a fortune as the owner of a lumber mill. He was also a naturalist and authored a book on salmon fishing. The property changed hands in 1927 and has descended through several generations to the present owners.

This chandelier hung in the living room of the Phair House, and the pair of lanterns (cat. 20) decorated the front foyer. The lanterns for both pieces were available through Stickley's 1905 catalogue, as model number 205.

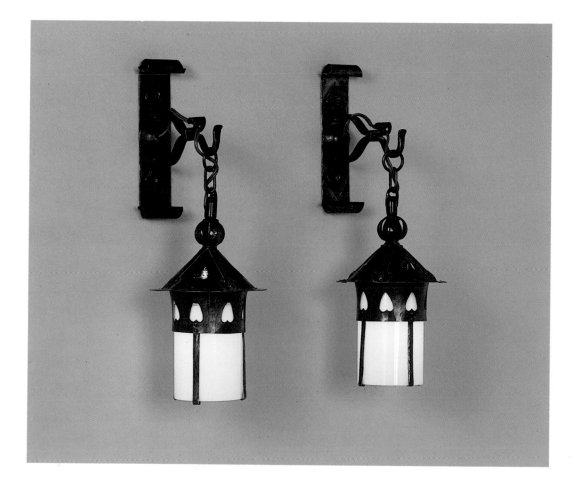

20.

Pair of Hanging Lanterns on Wall Brackets from the Phair House, Presque Isle, Maine, about 1906

Gustav Stickley

Iron and glass, each 11³/₄ x 10¹/₂

RECORDED: Gray and Edwards 1981, p. 149 no. 205 illus. an identical lantern

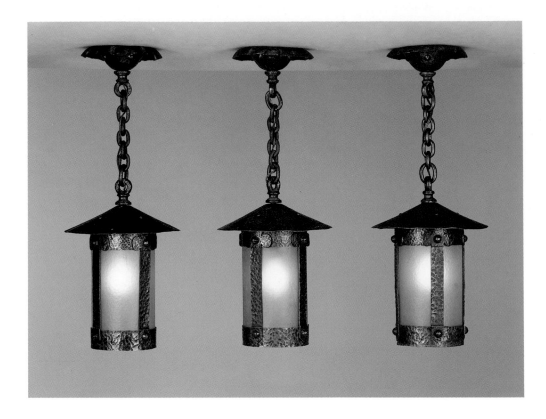

21.

*Five Lanterns from Dumblane House,
Washington, D.C.*, about 1912

Attributed to Gustav Stickley

Hammered brass, each 13 1/2 high

Dumblane House was built in 1911 by
Hazen S. Bond on the outskirts of Wash-
ington, D.C., from plans originally pub-
lished in a 1905 issue of *The Craftsman*
magazine. The plans and drawings were
prepared by Craftsman architects under
the direction of Mr. and Mrs. Bond, who
also supervised the design of the garden,
as well as every detail of the house, from
china patterns to the built-in furniture and
fixtures that were made at the Craftsman
Workshop. Bond himself even made
several pieces of furniture for the house,
including a tall-case clock that still stands

in its central hall. In all likelihood, these
lighting fixtures were designed by Stickley
in collaboration with the Bonds especially
for Dumblane House.

In keeping with his concern for unified
interior design, Stickley produced lighting
fixtures of the purest and simplest design
to accompany his other furnishings.
Unlike the colorful floral designs of
Art Nouveau leaded-glass shades, the
Dumblane lanterns and wall sconces are
subdued and monochromatic, intended
to complement his furniture rather than
compete with it. Stickley's concern here is
not with decoration, but with workman-
ship, as expressed in the hammer marks
visible on the brass elements. The clover-
leaf pattern on the strap hinges of these
lighting fixtures is unique to Dumblane
House.

22.

Two Wall Sconces from Dumblane House,
Washington, D.C., about 1912

Attributed to Gustav Stickley

Hammered brass, each 12 high

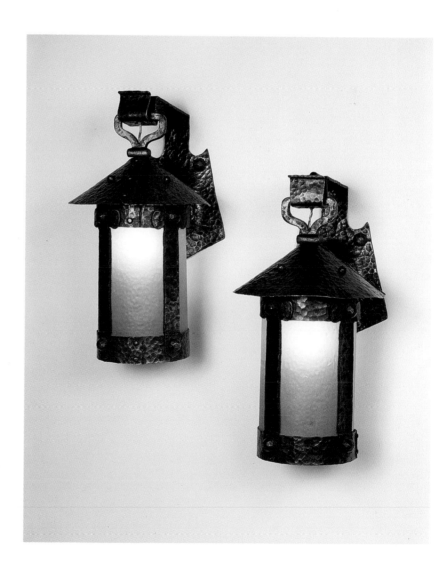

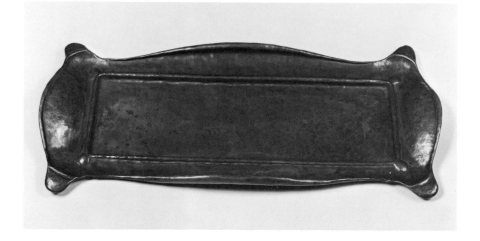

23.

Rectangular Serving Tray, about 1905

Gustav Stickley

Hammered copper, 23³/₄ x 10
Marked with circular die-stamp mark
(on the bottom): A L S / I K / K A N /
T H E - C R A F T S M A N - W O R K S H O P /
G U S T A V - S T I C K L E Y

R E C O R D E D : Gray and Edwards 1981,
p. 160 no. 354 illus. an identical example

In May 1902 Stickley opened a metal
workshop, where he produced sturdy
hardware for his massive structural pieces.
His concern for creating a total home
environment led him to produce accesso-
ries such as this tray. Using the same
metals as he used for his hardware, Stick-
ley intended these objects to complement
his furniture and to create unified interi-
ors. As with his furniture, Stickley
designed this tray to display the natural
qualities of the material, the only embel-
lishment being the hammer marks still
visible on the surface.

Leopold Stickley

1869–1957

John George Stickley

1871–1921

24.

Hall Armchair, about 1906–12

Leopold Stickley
John George Stickley

Oak, with leather upholstery,
47 x 28¹/₂ x 22
Marked with red decal (on back leg):
L & J G STICKLEY/HANDCRAFT

This massive hall armchair is reminiscent
of Gustav Stickley's heavy Mission-style
furniture, on which L. and J. G. Stickley
based many of their own designs. The
unusually broad and tall back is accented
by a slightly arched top stretcher.

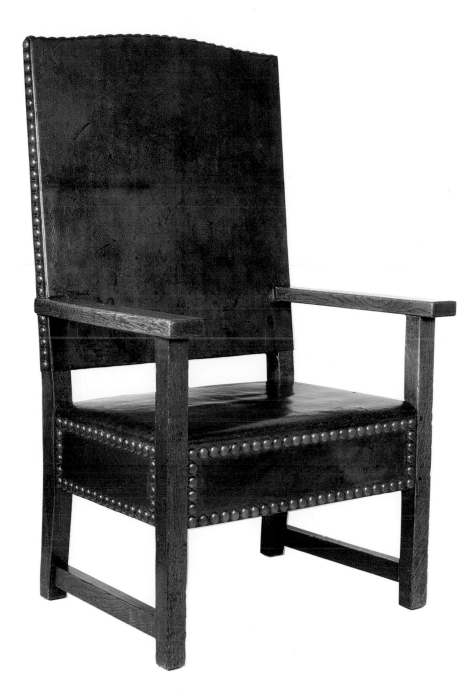

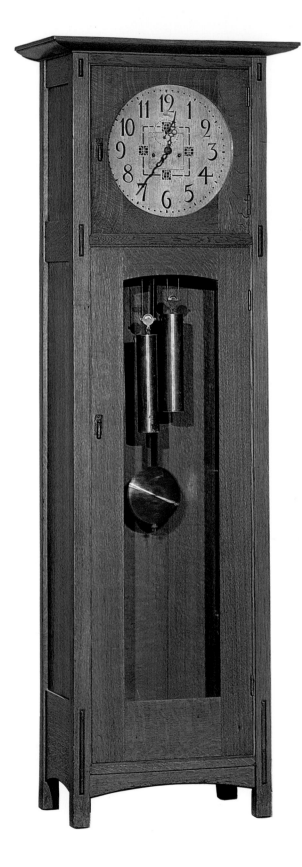

25.

Tall Case Clock, about 1908

Leopold Stickley
John George Stickley

Oak, with iron hinges, 80¹/₄ x 27 x 16³/₄
Marked (on clock face): L & J G STICK-
LEY FAYETTEVILLE/HANDCRAFT;
(on the back): red Handcraft decal

RECORDED: Gray and Trapp 1983b, p.
135 no. 86 illus. an identical example //
Kathleen Quigley, "A Stickley Grandson
Keeps Family Heritage Alive," *The New
York Times*, May 12, 1983, p. C6

EXHIBITED: The Everson Museum of
Art, Syracuse, New York, 1985, *Syracuse
Collects Arts & Crafts & Made in Syra-
cuse Today: Contemporary Work in
Wood*, as *Clock*, dated about 1912

EX COLL.: Gustav Stickley; by gift to
Mrs. Robert Bonner; to Peter Wiles, Sr.,
the artist's grandson, until 1988

According to family tradition, this clock
was made by Leopold Stickley for his
brother Gustav. Gustav gave the clock as
a gift to Mrs. Bonner, who later returned
it to the Stickley family. It remained in
their main residence at 438 Columbus
Avenue, Syracuse, until 1988. While
L. and J. G. Stickley designed another
version of the tall case clock (Gray and
Trapp 1983b, p. 135 no. 91), the large
size, elegant proportions, and fine detail-
ing of this particular clock, which retains
its original fittings, pendulums, and inter-
nal works (probably by Seth Thomas),
make it the best of its kind.

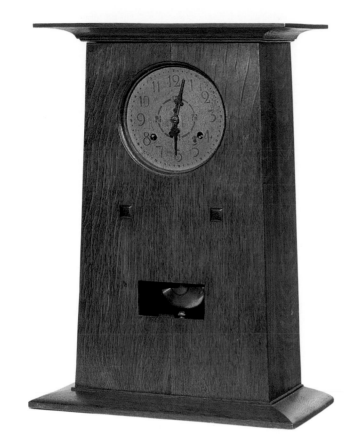

26.

Shelf Clock, about 1910

Leopold Stickley
John George Stickley
Peter H. Hansen (1880–1947), designer

Oak, with copper-plated face, 22 x 16 x 8

EXHIBITED: Boston 1987, p. 168 no. 53 illus. an identical example

EX COLL.: Robert Edwards, Philadelphia, until 1987

The design of this clock has been attributed to Peter H. Hansen (1880–1947), who was employed by Leopold and John George Stickley as a designer and mill foreman after about 1909. Hansen may have styled this clock after one by Ferdinand Christian Morawe, which was illustrated in the December 1903 issue of *Dekorative Kunst* (see Boston 1987, p. 88 fig. 18). The Stickleys were known to have subscribed to this magazine, and it is likely that Hansen would have read it to keep informed about the latest design trends.

27.

Book Table, about 1910

Leopold Stickley
John George Stickley

Oak, 28¹/₄ x 26¹/₄ x 26¹/₄
Marked with red decal (underneath the top): L & J G STICKLEY/HANDCRAFT

RECORDED: Gray and Trapp, p. 114 no. 516 illus. an identical example

EXHIBITED: Boston 1987, p. 383 no. 206 illus. an identical example

The design for this book table derives from the popular nineteenth-century revolving bookcase form. Gustav Stickley published a similar "combination table and encyclopedia bookcase" with ornamental slats in 1909 (see Gustav Stickley, *Craftsman Homes* [New York: Craftsman Publishing Company, 1909], p. 178).

28.

Morris Chair, about 1912

Leopold Stickley
John George Stickley

Oak, with leather upholstery,
40 x 33³/₄ x 36¹³/₁₆
Marked with branded mark (on back
stretcher): THE WORK OF/L.& J.G.
STICKLEY

RECORDED: Princeton 1972, p. 44 no.
48 illus. an identical example // Gray and
Trapp 1983b, p. 95 no. 471 illus. an
identical example

The Morris chair was one of the most
important pieces of furniture in the Arts
& Crafts Movement. The comfort and
adjustability of the chair, originally devel-
oped by Morris & Company during the
1860s, made it one of the most popular
designs of the period, and American furni-
ture companies continued to manufacture
the chair until as late as 1918.

This L. and J. G. Stickley chair appeared
in their 1910 catalogue. The shopmark
branded into the wood was used by the
firm between 1912 and 1918.

Tiffany Studios

New York, 1902–1938

29.

Pair of Tiffany Studios Leaded-Glass Hanging Lamps, about 1902–19

Tiffany Studios

Radiating bands of mottled green leaded glass, with bronze ring, hood, and chain, each 16¹/₂ x 12
Marked (on rim of shade): Tiffany Studios New York

The Louis C. Tiffany firm officially became Tiffany Studios in 1902, after relocating from Corona, Queens, to 45th Street and Madison Avenue in Manhattan. Most of Tiffany's leaded-glass shades were produced at this Madison Avenue location.

These Tiffany Studios shades are studded with large, circular glass "jewels" that provide textural contrast to the leaded and bronze surfaces.

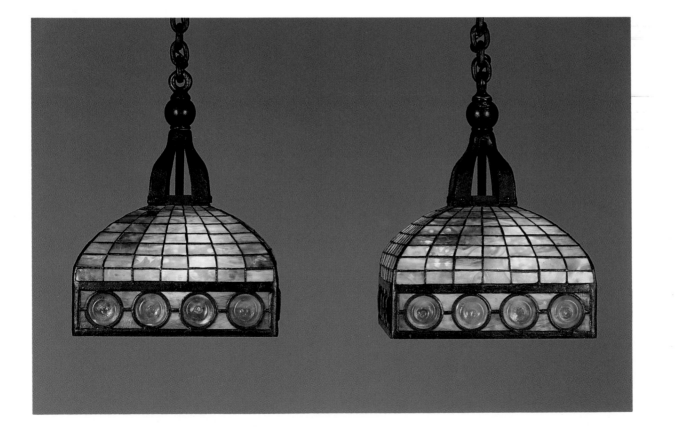

Tiffany Studios

New York, 1902–1938

Grueby Pottery Company

Boston, 1907–1913

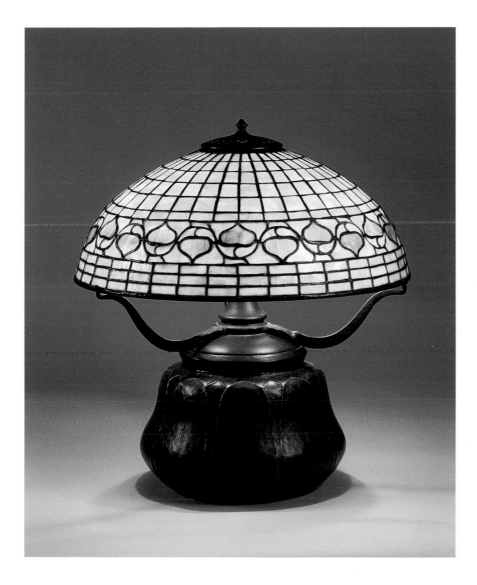

30.

Table Lamp with Tiffany Studios Vine Border, Leaded-Glass Shade, and Grueby Pottery Base, about 1907

Tiffany Studios
Grueby Pottery Company

Shade: radiating bands of green leaded glass centering a band of reversing heart/acorn-shaped grape leaves, on bronze ring, 10 x 16
Marked (on rim of shade): Tiffany Studios New York
Base: ceramic with matte green glaze, 7³/₄ high
Impressed mark (on the bottom):
GRUEBY POTTERY / BOSTON USA
Initialed (with incised mark, on the bottom): AL [Annie V. Lingley]

RECORDED: Volpe and Cathers 1988, p. 159 color pl. 110 a similar example

Wide-mouthed ceramic vases, to which Tiffany added shades and embellishments, were purchased from the leading art potteries, particularly Grueby, even after Tiffany Studios established its own ceramic division in 1905.

Annie V. Lingley (active 1899–1910), whose initials appear on the bottom of this Grueby lamp, executed the piece after a designer's pattern, probably the architect Addison LeBoutillier, who succeeded George P. Kendrick as Grueby's chief designer in 1901.

Fulper Pottery

Flemington, New Jersey, 1805–1955

Vase-Kraft

1910–1929

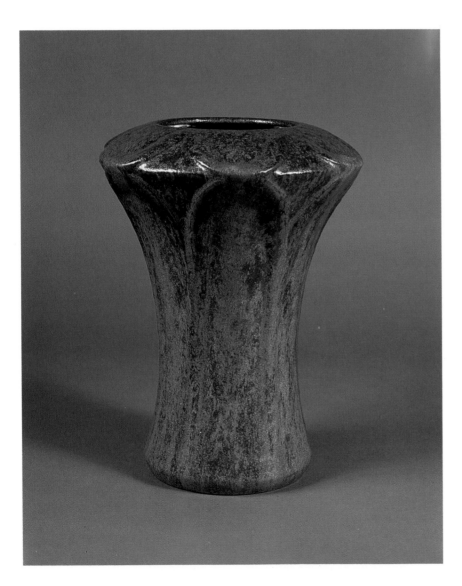

31.

Baluster-Shaped Vase with Flared Base and Mouth, about 1918–22

Fulper Pottery

Ceramic with copper-dust crystalline glaze, 11 1/8 high
Marked (in raised vertical rectangle with rounded corners around vertical mark, on the bottom): F /U /L /P /E /R

RECORDED: Volpe and Cathers 1988, pp. 21, 91, 93 pl. 59 an identical example, 94, 190 n. 36

In 1910 Fulper Pottery of Flemington, New Jersey (the oldest pottery manufacturer in the United States), introduced its art pottery line, Vase-Kraft. The Vase-Kraft line employed the widest range of unique glazes, whose colors and shapes derived from Chinese pottery.

Among Fulper's most highly esteemed glaze, albeit least predictable to fire, was the crystalline. At the 1915 Panama-Pacific Exposition in San Francisco, the crystalline glazes were lauded as "ceramic curios" ("Jersey Pottery Wins Honors at International Fair," *Pottery and Glass*, [July 1915], pp. 9–10). Copper-dust is the rarest of the crystalline glazes. This Vase-Kraft copper-dust vase, style no. 952, is one of only three known examples.

Grueby Faience Company
Boston, 1897–1909

Grueby Pottery Company
Boston, 1907–1913

Grueby Faience and Tile Company
Boston, 1909–1920

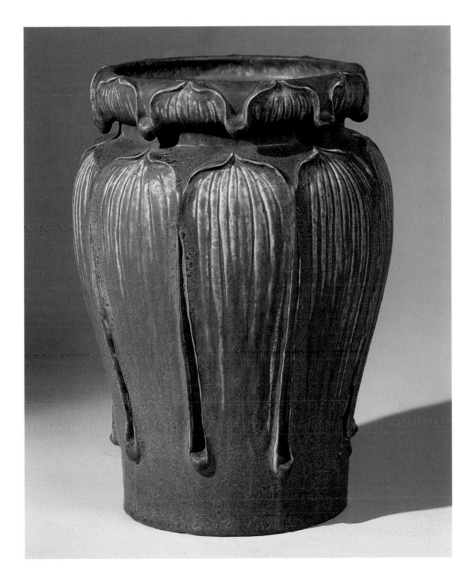

32.

Double-Tiered "Cucumber Green" Vase, about 1900

Grueby Faience Company

Ceramic with matte green glaze, 11³/₄ high
Marked and numbered (with impressed marks, on the bottom): GRUEBY FAIENCE CO./BOSTON U.S.A./34

RECORDED: Johnson 1988, p. 286 illus. an identical example

EXHIBITED: Universal Exposition, St. Louis, Missouri, 1904, Department B-Art: Applied Arts / Group 14 / Original Objects of Art Workmanship, pp. 82–83 nos. 370, 376–77, may be identical examples

As the foreword to the catalogue of the *Universal Exposition,* organized within the Louisiana Purchase Exposition of 1904, states, "Applied Art" was accorded the same importance as "Fine Arts." In that same exposition, the French architect-designer Addison LeBoutillier and his collaborator, William H. Grueby, exhibited forty objects in the Applied Arts section. They were awarded the Grand Prize. Three of the vases exhibited may have been of the same type as the present example.

The raised-leaf decoration on this vase, with its fluid lines, is most evocative of Art Nouveau design, whose vocabulary Grueby adapted to his earliest vessels. As with other Grueby vases, the relief was created by first incising the surface, then applying thinly coiled pieces of clay to selected areas of the incision.

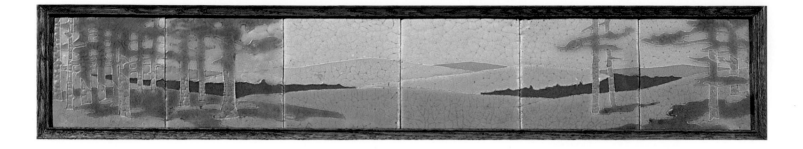

33.

The Pines: Frieze of Six Tiles Decorated with Stylized Pines, a Lake, and Mountains, about 1906–20

Grueby Faience Company
Grueby Pottery Company
or Grueby Faience and Tile Company
Addison B. LeBoutillier (1872–1951), designer

Buff terracotta, with press-molded design covered in green, blue, and ocher matte glazes, 6¹/₁₆ x 36⁷/₁₆
Four tiles each initialed (on the back): LC [or DC]

RECORDED: Princeton 1972, cover illus. a similar example // Boston 1987, pp. 25 illus. in color, 259 no. 119 a similiar example (collection of the Museum of Fine Arts, Boston)

Architectural tiles were the mainstay production of the Grueby Faience Company. At the age of fifteen, William Grueby served an apprenticeship at the Low Art Tile Works in Chelsea, Massachusetts. In 1894, he formed his own terracotta manufacturing company.

Grueby tiles were created by pressing clay into molds whose raised ridges were predetermined. Matte glazes were then applied between areas of relief, and the tiles fired, resulting in a cloisonné effect.

The Pines frieze was originally designed as a set of eight tiles; only six survive intact.

Fireplace Surround, 1902

Grueby Faience Company (1897–1909)

Addison LeBoutillier (1872–1951), designer

Buff terracotta, with press-molded design covered in green, and shades of brown and rust matte glazes, 64⅞ x 84⅜

EX COLL.: commissioned by Joseph Sellwood on the occasion of the marriage of his daughter Othelia to Lesley W. Leithhead, Duluth, Minnesota, in 1902; to Mr. and Mrs. Lesley W. Leithhead, Duluth, Minnesota, 1902–46; to Sellwood-Leithhead mansion, Duluth, Minnesota, 1946–87

Grueby tiles were frequently employed in conjunction with architectural elements—integrated into entry halls, bedrooms and bathrooms, fireplaces and furniture—or framed as individual works of art. The designs on both tiles and vases were drawn from nature. Elegant curvilinear patterns, repeated from left to right in mirror image, as in the fireplace surround, recall French Art Nouveau, one of Grueby's earliest stylistic sources.

This fireplace surround was designed by LeBoutillier specifically for the Sellwood-Leithhead mansion in Duluth, Minnesota. In 1902, Joseph Sellwood, an iron-mine magnate, commissioned the Duluth architectural firm of Palmer, Hall and Hunt to build a house as a wedding present for his daughter Othelia. The exterior of the mansion was constructed of sandstone in Romanesque Revival style, and the interior decorated in the Arts & Crafts mode. In addition to the work by Grueby, several fireplace surrounds and lamps for the mansion were designed by Tiffany Studios.

35.

Vase with Pointed, Overlapping Tooled Leaves and Stepped-in Neck, about 1907

Grueby Faience Company
Norma Pierce, decorator

Ceramic with matte green glaze, 9¹/₂ high
Impressed mark (on the bottom):
GRUEBY FAIENCE CO. / BOSTON
USA
Initialed (with incised mark, on the bottom): P [in triangle]
Numbered (with impressed mark, on the bottom): 135

Grueby pottery is distinguished by its hand-thrown vessels and lush matte green glaze. Although Grueby employed a variety of colored glazes, such as white, yellow, blue, and brown, it was the Grueby green glaze that brought the pottery renown. In fact, the green glaze was so popular that other art potteries, such as Teco and Rookwood, attempted to duplicate it. Here, the unadorned relief of overlapping leaves accent the simple lines of the vase.

Marblehead Pottery

Marblehead, Massachusetts, 1904–1936

36.

Vase with Floral Motif, about 1910

Marblehead Pottery
Arthur Eugene Baggs (active 1905–25), designer

Ceramic with matte glazes, 6 high
Initialed (with impressed mark, on the bottom): M / M P

RECORDED: Eidelberg 1987, pp. 38–39 pls. 62, 64–67 illus. similar examples

This refined vase decorated in muted colors is typical of the vessels produced by Marblehead Pottery. The repeated design surrounding the vase in horizontal and vertical bands represents stylized botanical forms. The entire surface is covered with a unifying transparent matte glaze.

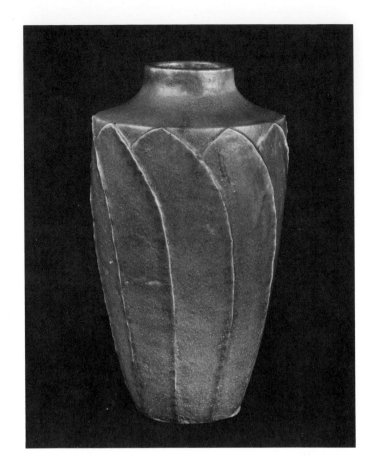

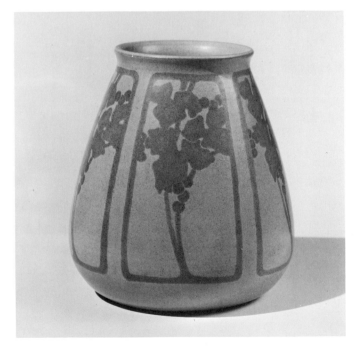

Newcomb Pottery

New Orleans, Louisiana, 1897–1948

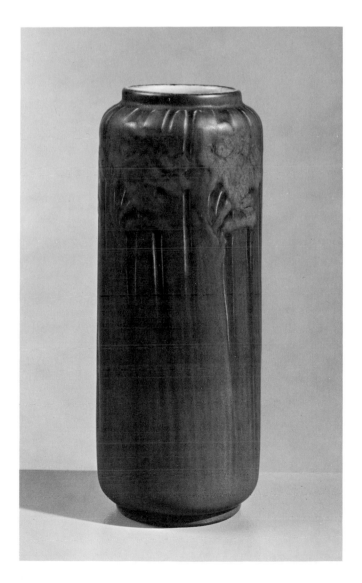

Tall Vase with Freesia Relief, 1911

Newcomb Pottery
Joseph Fortune Meyer (1848–1931), potter
Anna Frances Simpson (active 1908–23, 1924–29), decorator

Ceramic with green semi-matte glaze, 9$^1/_2$ high
Impressed and painted mark (on the bottom): N within a larger C [Newcomb College]
Initialed (with impressed mark, on the bottom): JM [Joseph Fortune Meyer]
Initialed (with incised and painted mark, on the bottom): A F S [Anna Frances Simpson]
Clay body and glaze mark (with incised mark, on the bottom): B within a circle [Buff clay body with a semi-matte glaze]
Registration number (painted on before glazing, on the bottom): E W . 87

RECORDED : Poesch 1984, pp. 89–91, 94, 105, 135 no. 145 illus. similar decoration

This vase is one of the earliest examples of the transparent semi-matte glaze introduced by Newcomb Pottery after 1910, in response to the popularity of Grueby's matte glazes. It is also an outstanding example of the successful marriage between the vessel's form and the low relief, painted decoration.

Newcomb Pottery was established to give instruction in pottery decoration to young women students attending the H. Sophie Newcomb Memorial College in New Orleans. Since the emphasis was on decoration, the vessel shapes were comparatively uniform. But the decoration was highly diverse; each unique piece was juried by the art faculty before its release.

Samuel Yellin

1885–1940

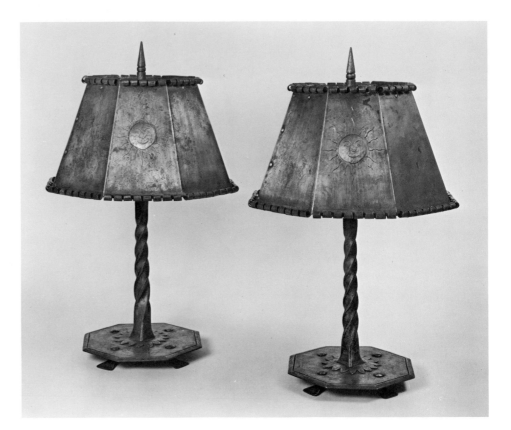

38.

Pair of Table Lamps, about 1915
Samuel Yellin

Wrought iron, each 21½ high
Marked (at the base of the shade):
SAMUEL YELLIN

Samuel Yellin was one of a distinguished group of blacksmiths who produced hand-forged objects before the Depression and World War II made such work impractical (Boston 1987, pp. 137–38). Born in Poland, he learned the fundamentals of his trade by working in shops in Germany, Belgium, and England. In 1906 he immigrated to Philadelphia.

Yellin opened his first shop in 1909. When he began undertaking commissions

for architects, particularly the successful firm of McKim, Mead, and White, he expanded his facilities. His Arch Street Metalworker's Studio, designed by Walter Mellor and Arthur Meigs and completed in 1915, not only included a showroom, library, museum room, and drafting room, but also a vast work space large enough to accommodate sixty forges and more than two hundred workers. To ensure the quality of his production, Yellin carefully selected his craftsmen, who were hired to perform specific tasks, including chisel decoration, *repoussé*, and polishing.

A true artisan, Yellin fervently believed in the tradition of forging with hammer and anvil. He studied, as well as lectured on,

the history of his craft, and his well-stocked library functioned as a rich source of information and ideas that enhanced his own work. Yellin's emphasis on forging techniques was in perfect accord with the Arts & Crafts orientation to craftsmanship.

The textures and colors that distinguish Yellin's work, including these lamps, would be impossible to achieve through ordinary casting and welding techniques. While Yellin was not against using standard-size rods, bars, and plates as substrates for his designs, or employing electronically controlled blowers to ensure an optimal temperature during forging, he always brought to his production a personal vision, quality, and touch.

Marie Zimmermann

1878–1972

39.

Bowl, about 1922

Marie Zimmermann

Patinated copper and blue paint,
3³/₄ x 15 x 7¹/₄
Marked (on the bottom): M Z cipher
encircled by MARIE ZIMMERMANN-
MAKER

RECORDED: Boston 1987, pp. 270–71
no. 132 illus. an identical example //
Doris Saatchi, "Precious Metals: The
Work of Marie Zimmermann is Rediscov-
ered," *House & Garden*, 161 (June
1989), pp. 150–51 illus. in color, 170

Private Collection

The daughter of Swiss parents, Zimmer-
mann designed and practiced various
handicrafts, painting, and sculpture, but
she gained national renown with her
metalwork and jewelry. She began her
career by taking courses at the Art Stu-
dents League, New York, and exhibiting
work at the Art Institute of Chicago in
1903. Important recognition came in
1915 and 1916, when she exhibited her
work at Ehrich Galleries, New York.
During the early 1920s her work was

reproduced in various publications,
including *The International Studio*, *Arts
& Decoration*, *House & Garden*, and
Vogue. The scope of her production
ranged from fan holders, candlesticks,
tableware, and furniture to important
architectural metalwork commissions in
the East and Midwest.

Like other Arts & Crafters of her genera-
tion, Marie Zimmermann looked to the
antique as an inspiration for her own
modernist work, and she frequented the
Metropolitan Museum, where she studied
handcrafted objects in the Egyptian, Far
Eastern, and Greek rooms. She also stud-
ied ancient methods of patination and
devised her own techniques—using vari-
ous chemical treatments, gilding, and
plating—that simulated the rich colors
and surface textures of these earlier
models.

This bowl, made of planished copper and
based on the Chinese polylobed beaten
silver dishes of oval or pointed oval shape
popular during the T'ang Dynasty, is one
of Zimmermann's many patinated varia-
tions of petal bowls. Its design is simple
and elegant, stylized and naturalistic.

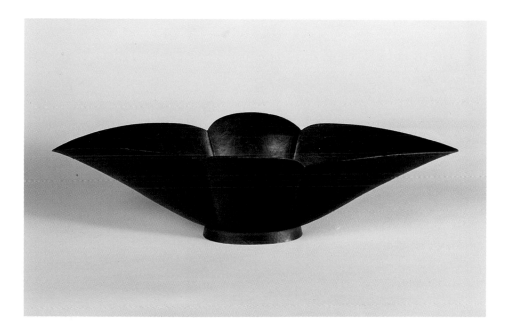

The Midwest

It should come as no surprise that the Midwest was the locus of much Arts & Crafts activity. Fueled by an influx of immigrants and settlers from other parts of the country, all eager to participate in the burgeoning growth of the region, the prairies were settled and civilized. Art and aesthetics played a major role in this cultural transformation. By the early twentieth century, the Midwest had been host to two major expositions that greatly influenced the course of design in the decades that followed: the World's Columbian Exposition of 1893 in Chicago and the Louisiana Purchase Exposition of 1904 in St. Louis. The former represented the apotheosis of the "American Renaissance" through European Beaux-Arts influence; the latter brought before an American public the new, modern designs of the Arts & Crafts Movement, through the stylish, utilitarian work of Gustav Stickley, Charles P. Limbert, William Grueby, and others.

By the 1890s, Chicago had become a locus of avant-garde architecture. Louis Sullivan, whose firm of Adler & Sullivan helped to formulate modern architecture in America, produced seminal works such as the Wainwright Building in St. Louis (1890–91) and the Carson-Pirie-Scott department store in Chicago (1899–1904), which placed the Midwest in the forefront of architectural innovation. Sullivan was no less important as a teacher, for it was in his drafting rooms that Frank Lloyd Wright, George Grant Elmslie, William Gray Purcell, and others served their apprenticeships.

Wright's work is not only crucial to the development of architecture in the twentieth century, but is also an important source of Arts & Crafts design in the period 1898–1915. Many of his designs show an affinity with the Mission-style furniture being produced by the Stickleys, Elbert Hubbard, and others, and their philosophies of incorporating art into everyday life were similar. But Wright's insistence on the totally designed environment and the subjugation of furnishings to architecture took the Arts & Crafts ideology one step further. His synthesis of Sullivan's organic ornament with the simplified lines and forthright construction characteristic of the Arts & Crafts Movement was fully developed in the work of such Prairie School architect-designers as Purcell, Elmslie, George Washington Maher, and Wright's own apprentices, Walter Burley Griffin and Marion Mahoney Griffin.

Wright was never one to insist on the handcrafting of objects, but he did maintain loyal relationships with the manufacturing firms and craftsmen who executed his designs. Fore-

Frank Lloyd Wright
Stained-Glass Window, Coonley house (detail). CAT. 60

most among them was George Mann Niedecken of Niedecken-Walbridge Company—one of the first firms to identify itself as being in the business of interior design—which supervised the interiors of some of Wright's most important and impressive Prairie-style projects of the Oak Park period. Niedecken was first employed by Wright as a mural designer (see cat. 64) and he also delineated designs by Wright before producing his own furniture and interiors.

The Midwest was also home to other Craftsman-inspired firms, which adhered more closely to the principles set forth by Gustav Stickley and Elbert Hubbard on the East Coast. Charles P. Limbert, who established his Holland Dutch Arts and Crafts furniture company in Grand Rapids and Holland, Michigan, in 1902, was a self-styled promoter like Elbert Hubbard, and he marketed largely eclectic designs based on the Mission furniture he knew to be successful. His best work was based on that of the British designers Charles Rennie Mackintosh, C.F. Voysey, and M.H. Baillie Scott; in his synthesis of their more lyrical European style with the American version of the Arts & Crafts aesthetic, he achieved some truly fine results.

Oscar Onken, having been impressed with both the Stickley and Austrian exhibits at the Louisiana Purchase Exposition, established The Shop of the Crafters in Cincinnati in 1904. He hired the Hungarian designer Paul Horti, who had worked on the Austrian exhibits at the fair, and together they created a distinctly European air in their furniture, distinguished by its use of inlays, applied carving, and painted designs (Boston 1987, p. 248).

The Midwest proved fertile ground for a host of craftsmen and manufacturers who produced decorative objects in metal and, especially, ceramics. Robert Riddle Jarvie, active in Chicago from 1905 to 1917, was famous for his cast bronze and copper candlesticks, as well as for his gold and silver presentation pieces. Art potteries sprang up by the dozen across the Midwest in the years 1880 to 1910, many of them founded by women who relished the opportunity to establish businesses in one of the few enterprises open to them. Ohio was particularly blessed with talented ceramists such as Mary Louise McLaughlin and Maria Longworth Nichols, both in Cincinnati. In 1880 Nichols established the famous Rookwood Pottery, which functioned as art school, pottery, and social center. The largest and most successful Arts & Crafts pottery was probably Roseville, opened in 1892 in Zanesville, Ohio.

Gates Pottery was established around 1885 in Terra Cotta, Illinois. Under the guidance of William D. Gates it became an important source of art pottery for the architects of the Prairie School, as well as for collectors of Arts & Crafts ceramics. The firm's Teco line, characterized by its architectural forms and matte green glazes, was first exhibited in 1900 and later won honors at the Louisiana Purchase Exposition. Architects such as William B. Mundie, Howard Van Doren Shaw, Hugh M.G. Gardner, and Frank Lloyd Wright all contributed pottery forms they felt would be appropriate for the Prairie School interiors they were designing for their architecture.

The confluence of art, industry, and individual endeavor characteristic of the Arts & Crafts Movement was rarely better demonstrated than in the breadth and variety of activity that flourished in the Midwest at the turn of the century. Both in furniture and decorative arts, Arts & Crafts design reflected specific regional influences. From the modernist works produced in and around sophisticated Chicago, to a more populist synthesis of East Coast Arts & Crafts design in Ohio and Michigan, to the innovative work done in ceramics by a new breed of female artisans cum entrepreneurs, the Arts & Crafts Movement proved to be a rich and elastic matrix for American design.

ANN YAFFE PHILLIPS

George Grant Elmslie

1871–1952

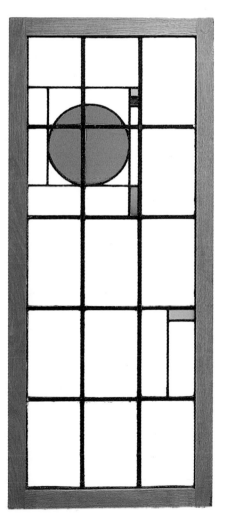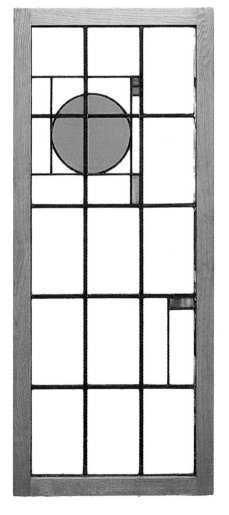

40.

Pair of Windows from the Henry B. Babson House, Riverside, Illinois, about 1924

George Grant Elmslie

Leaded glass, each 44¹/₂ x 16¹/₂

EX COLL.: Henry B. Babson, Riverside, Illinois, until about 1960; to Mr. Holt, Riverside, Illinois; to his wife, until 1986; to (Christie's, New York, June 13, 1986, lots 88 and 89); to (Don Magner, Brooklyn, New York)

Henry B. Babson's house in Riverside, Illinois, was designed by Louis Sullivan in 1907 and completed in 1909. George Elmslie was then employed by Sullivan and was responsible for designing the interior, including furnishings and ornamental windows. This was his last project before leaving to form his own firm with William G. Purcell and George Feick, Jr. in 1910. Babson was a man who loved architecture and remodeling and was known to have commissioned architects to design additions to his house that he had no intention of building. He did retain Elmslie on two separate occasions to make revisions to the house which were executed—once in 1912–13, when a sleeping porch was enclosed and new ornamental glass installed, and again around 1924, when second stories were added to several of the wings. The present windows date from the later remodeling and were probably installed in the new upper stories. There are eight similar windows known to exist, each with slight variations.

Henry Babson tried unsuccessfully to sell his house to the town of Riverside around 1960, but was eventually forced to sell to a developer. Before the house was demolished, a removal sale was held, at which time these windows, as well as other interior fittings and ornaments, were sold.

William Gray Purcell

1880–1964

George Feick, Jr.

1881–1945

George Grant Elmslie

1871–1952

41.

Pair of Director's Armchairs for the Merchants Bank, Winona, Minnesota, about 1911–12

William Gray Purcell
George Feick, Jr.
George Grant Elmslie

Oak, with original green leather upholstery and brass tacks, 37 x 24¹/₄ x 24

RECORDED: Boston 1987, pp. 201–02, 203 no. 92 illus. an identical example, 204 // Volpe and Cathers 1988, p. 60 no. 34 illus. in color an identical example

Among the most successful Prairie School architectural firms after Frank Lloyd Wright was Purcell, Feick, and Elmslie, established in 1910. It later became Purcell and Feick (1907–09), Purcell, Feick and Elmslie (1910–13), and finally Purcell and Elmslie (1913–22). Purcell and Feick were fellow classmates at the Cornell University School of Architecture; later, Purcell met Elmslie in the office of Louis Sullivan during his five-month employment there (Elmslie spent twenty years working as an assistant to Sullivan). The eventual collaboration of these three architects produced a series of fruitful works. In addition to their many residential commissions, the firm also undertook commissions for banks, many of which were located in small, parochial towns throughout the upper Midwest. Following the lead of Sullivan and Wright, they avoided overt Beaux-Arts detailing and neo-Geor-

gian designs in order to create an unpretentious, indigenous American style. As commercial architecture, these edifices were distinguished by their steel frames, brick facades with pier-and-lintel articulation, stylized terracotta ornament, arched entries, clerestory windows, stained glass, and integrated interiors.

Being a Minnesota-based firm, Purcell, Feick, and Elmslie undertook numerous local commissions, including private residences, municipal buildings, and commercial banks. In the Merchants Bank in Winona (now the Merchants National Bank), completed between 1911 and 1912, they achieved their most successful marriage of decorative and functional design. In their original rendering for the Merchants Bank (*The Western Architect*, 19 [January 1913], p. 20), they conceived a square, volumetric box compartmentalized into public spaces—a central lobby and waiting room—and more private spaces for offices and conference chambers. The interior was a single two-story space divided into secondary enclosures at the ground level. External and internal ornament, including brickwork, terracotta, lighting fixtures, stained glass, and furniture, was integrated into the total design.

This pair of armchairs is from a set of eight chairs designed originally for the directors boardroom. Similar chairs were also used in the bank's waiting room (David Allen Hanks, "The Prairie School

Interior," in *Prairie School Architecture*, exh. cat. [St. Paul: Minnesota Museum of Art, 1982], p. 90) as well as in other private offices. But the director's chairs are distinguished by a wider back rest, slight extensions rising from the back of each armrest, and green leather upholstery, which covers the entire seat and is secured with brass tacks.

The fundamental design of all these chairs, being modular and geometric, is related to Wright's chairs of the 1890s and also recalls similar furniture designs by the Austrian Koloman Moser, whose work Purcell would have encountered during his travels abroad from 1903 to 1907. In general, these chairs, unlike some of Wright's, were designed for comfort. A utilitarian piece of furniture whose details were variously changed depending on the context and the commission, this type of chair appeared in other Purcell, Feick, and Elmslie interiors, including Purcell's own residence in Minneapolis (*The Western Architect*, 21 [January 1915], pls. 8–9).

During the early 1970s, the Merchants Bank underwent an extensive interior renovation. In the process, many of the original offices, including the director's boardroom and a waiting room, were eliminated, and the excess furniture was disposed of. Other directors chairs of this design are now owned by the Winona Historical Society and the Merchants National Bank of Winona as well as a private collection.

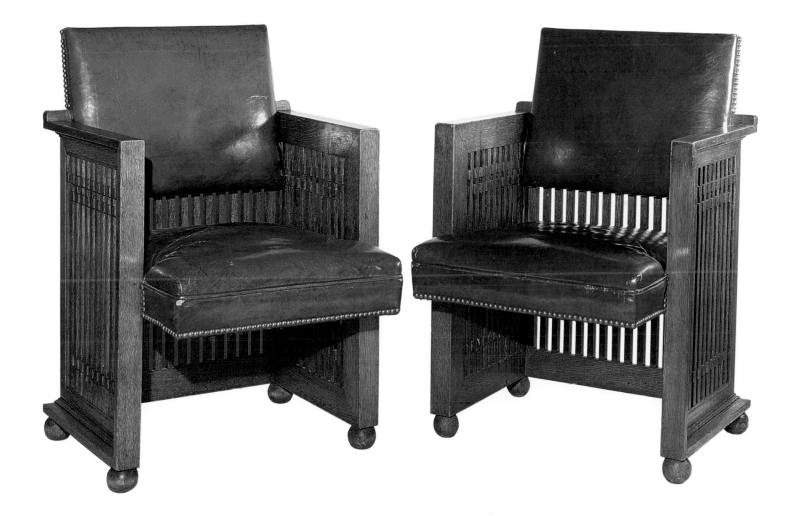

Charles P. Limbert

1854–1923

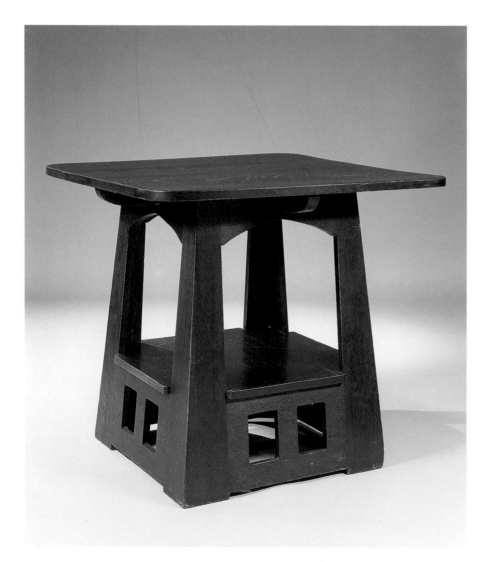

Square Center Table, about 1904

Charles P. Limbert

Oak, 30¹/₂ x 33¹/₂ x 33¹/₂

Marked with paper label (underneath top): Limbert/Arts Crafts/Furniture/Made in Grand Rapids

RECORDED: Grand Rapids 1987, p. 41 no. 26 illus. an identical example

Charles Limbert worked for the Chicago furniture firm of John A. Colby & Company during the 1880s. After arriving in Grand Rapids in 1889, he established, with Phillip Klingman, the Limbert and Klingman Chair Company. After two years the company was dissolved, and in 1894, C.P. Limbert & Company was formed.

Limbert's most innovative work was produced between 1904 and 1906. In this highly original table, a widely overhanging top is supported by a flaring base with a gently arching apron and lower shelf, whose sides protrude beyond the legs of the table. The base is pierced with Limbert's characteristic rectangles with rounded corners. The proportions and detailing of the table make it sophisticated and elegant.

43.

Square Cut Café Chair, about 1905

Charles P. Limbert

Oak, with linen upholstery, 34 x 26 x 20

Marked (with branded stamp, underneath left arm): Limbert/Arts Crafts/Furniture/ Made in/Grand Rapids and Holland

RECORDED: *Limbert's Holland Dutch Arts and Crafts Furniture*, p. 45 no. 500 illus. an identical example

Like many furniture designers in Grand Rapids, Limbert was aware of, and receptive to, international currents, particularly the work of Josef Hoffmann in Austria and Charles Rennie Mackintosh in Scotland.

For this café chair, Limbert drew inspiration from those in Mackintosh's Willow Tea Rooms, but modified the design slightly to conform to an American Arts & Crafts vernacular.

Constructed of horizontal and vertical planes of wood, the chair is austere without being too severe. Its design incorporates a large, cutout opening on the sides and a curvilinear pierced device on the back. Subtle modulations of volumes and planes serve to make this one of Limbert's most simple and elegant chairs.

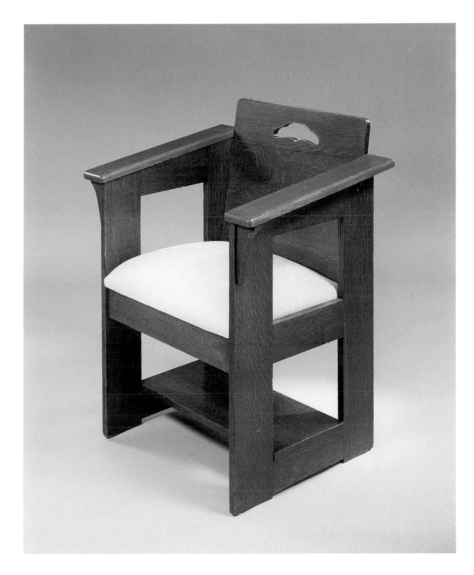

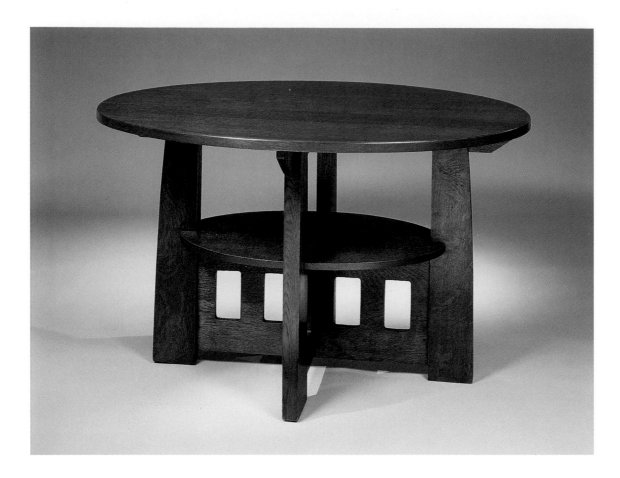

44.

Oval Center Table, about 1906

Charles P. Limbert

Oak, 30 x 36 x 48

RECORDED: *Limbert's Holland Dutch Arts and Crafts Furniture*, p. 50 no. 158 illus. an identical example

Limbert's center table, while recalling Mackintosh's designs for the Willow Tea Rooms of 1903, is more graceful and dynamic through its gently swelling legs and lower oval shelf supported by broad stretchers pierced by rectangular cutouts. The total effect is one of solidity and grace, which characterize Limbert's best designs.

45.

Armchair, about 1906

Charles P. Limbert

Oak, with leather upholstery,
40 x 27¹/₄ x 22

Marked with metal tag (on back leg
brace): Limberts/Art Crafts/Furniture/
Made In/Grand Rapids/and Holland

RECORDED: *Limbert's Holland Dutch
Arts and Crafts Furniture*, p. 45 no. 575
illus. an identical example

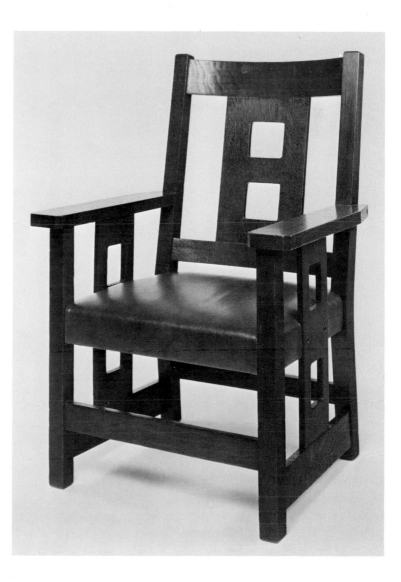

George Washington Maher

1864–1926

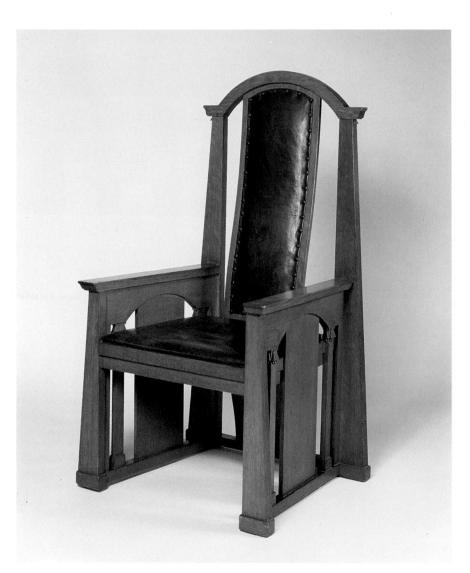

46.

Armchair from the E. L. King House, Homer, Minnesota, about 1912

George Washington Maher

Oak, with leather upholstery,
45³/₄ x 25¹/₄ x 22¹/₂

EXHIBITED: Boston 1987, pp. 47 no. 217 illus. in color, 398 no. 217 an identical example

This chair was designed for "Rockledge," the E. L. King House in Homer, Minnesota. Maher's design for the U-shaped house and all its furnishings was influenced by the English designer C.F.A. Voysey. Though Maher's earlier work was extremely ornate and monumental, he began to work in the less elaborate Voysey style after 1905.

The principal architectural device that Maher incorporated into "Rockledge" was the segmental arch with short flanges set on canted buttresses. He repeated this feature throughout the house and in many of its furnishings in order to unify the exterior design with the interior decor. This chair displays such signature architectonic qualities as the segmental pediment with moldings and guttae, tapered stiles, and wide base.

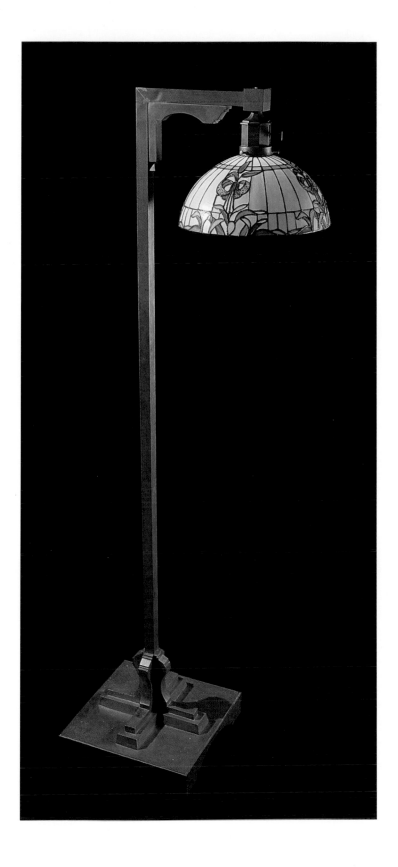

47.

Floor Lamp from the E. L. King House, Homer, Minnesota, about 1912

George Washington Maher

Steel lamp with stained-glass shade, 62 high; base, 14 x 14

This lamp, designed for "Rockledge," incorporates certain architectural devices used throughout the house, such as the segmental arches at the base and top, and the single gutta applied near the top as a decorative drop. Further unifying elements are the wild lily motif, a signature of "Rockledge" designs, and the colors of the glass in the shade, which link the lamp with the exterior landscaping.

The Shop of the Crafters at Cincinnati

1904–1920

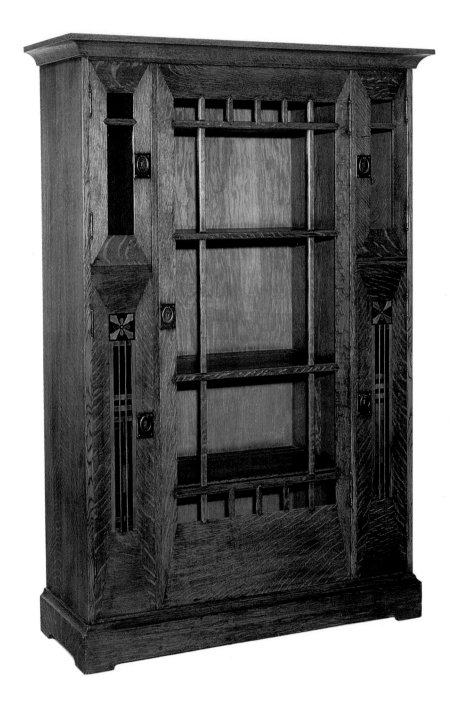

48.

Inlaid Oak China Closet, about 1906

The Shop of the Crafters

Oak, inlaid woods, and copper,
63 1/8 x 42 x 5 3/4

Marked with original paper label bearing lantern trademark (on the back): Shop of the/Crafters/at Cincinnati

RECORDED: Gray and Trapp 1983a, p. 7 no. 326 illus. an identical example

EXHIBITED: Boston 1987, pp. 21 pl. 106, 248 no. 106

EX COLL.: Robert Edwards, Philadelphia, until 1987

Oscar Onken (1858–1948), a prominent businessman and philanthropist, founded The Shop of the Crafters in Cincinnati, in 1904, in response to the popularity of Gustav Stickley's furniture. Although little is known of Onken's business career and his exact involvement with the Shop, he always seems to have had a penchant for art and furniture. Sporting an eclectic inventory, the Shop initially advertised itself as "Makers of Arts and Crafts Furniture, Hall Clocks, Shaving Stands, Cellarettes, Smokers' Cabinets and Mission Chairs." Within two years, however, the company began to focus exclusively on Mission and Arts & Crafts furniture. Onken developed a line of furniture that was decorated with inlays, applied carving, tiles, painted designs, and hardware, and stained with various finishes of his own invention. The pieces were marketed through trade journals, periodicals, dealers, and catalogues.

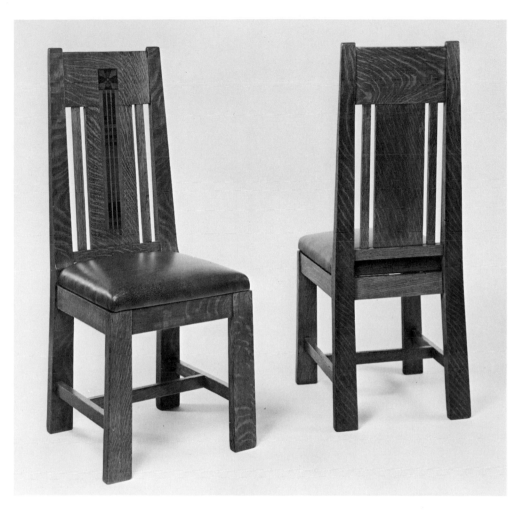

49.

Four Inlaid Side Chairs, about 1906

The Shop of the Crafters

Oak, with inlaid woods and leather upholstery, each 43 x 16¹/₄ x 18

Each marked with original paper label bearing lantern trademark (on back leg brace): Shop of the/Crafters/at Cincinnati

RECORDED: Gray and Trapp 1983a, p. 6 no. 320 illus. an identical example, as *Mission Dining Chair*

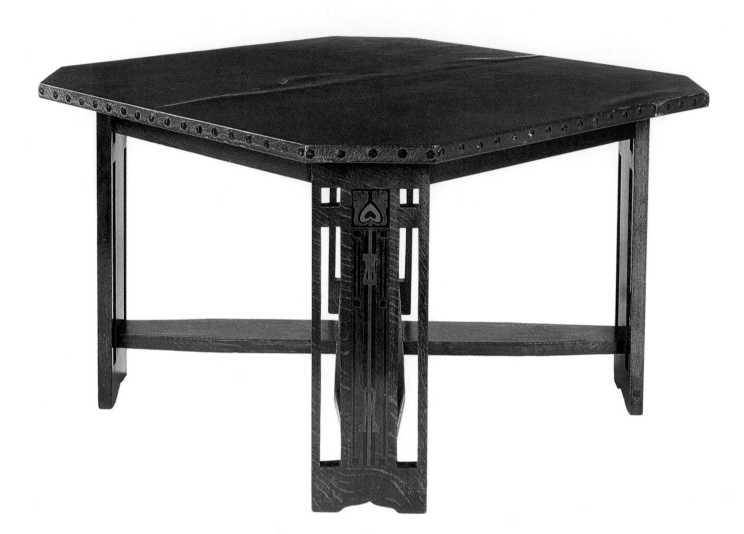

50.

Library Table, about 1906

The Shop of the Crafters

Oak, with inlaid woods, original Spanish leather, and brass tacks, 29¹/₂ x 48 x 48

Marked with original paper label bearing lantern trademark (underneath tabletop): Shop of the/Crafters/at Cincinnati

RECORDED: Gray and Trapp 1983a, p. 10 no. 335 illus. an identical example

51.

Settle, about 1906

The Shop of the Crafters

Oak, with inlaid woods, leather uphol-
stery, and brass trimmings,
37 x 66¹/₂ x 30¹/₄

Marked with paper label bearing lantern
trademark (on center bottom seat slat):
Shop of the/Crafters/at Cincinnati

RECORDED: Gray and Trapp 1983a,
p. 12 no. 334 illus. an identical example,
as *Mission Seat*

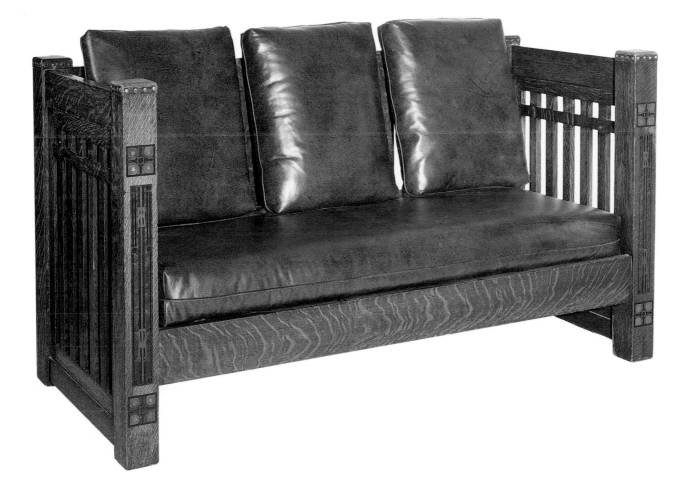

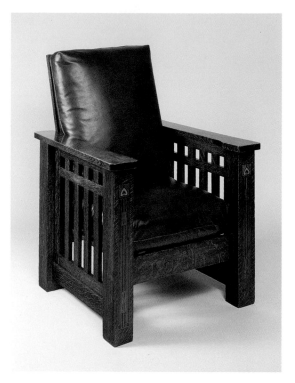

52.

Adjustable Reclining Chair, about 1906

The Shop of the Crafters

Oak, with inlaid woods and leather upholstery, 40¹/₂ x 29¹/₄ x 30¹/₄

Marked with original paper label bearing lantern trademark (on seat slat): Shop of the/Crafters/at Cincinnati

RECORDED: Gray and Trapp 1983a, p. 12 no. 333 illus. an identical example, as *Mission Morris Chair*

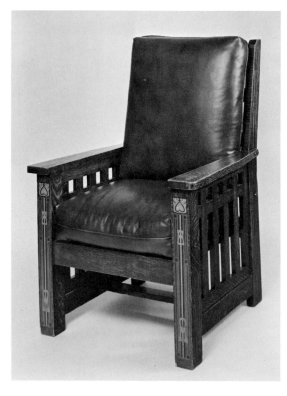

53.

Armchair, about 1906

The Shop of the Crafters

Oak, with inlaid woods and leather upholstery, 43¹/₂ x 28 x 28

Marked with original paper label bearing lantern trademark (on bottom back slat): Shop of the/Crafters/at Cincinnati

RECORDED: Gray and Trapp 1983a, p. 12 no. 331 illus. an identical example, as *Mission Arm Chair*

Frank Lloyd Wright

1867–1959

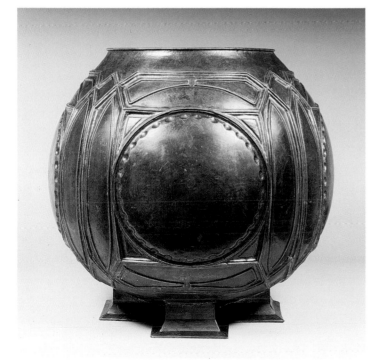

54.

Urn, about 1900

Frank Lloyd Wright

Repoussé copper, $18^{1}/_{2}$ x $18^{1}/_{2}$ diameter

Executed by James A. Miller

This particular urn first appeared in the Edward C. Waller house in 1899, and subsequently in several other projects, including the B.H. Bradley house in Kankakee, Illinois, the Dana house, Browne's Bookstore, the Coonley house, and Wright's own residence. There are two versions of the urn: a simpler design lacking secondary panel decoration; and the one illustrated here, which has a more complex arrangement of square and circular motifs.

The urn's interlocking geometric patterns, created by a series of overlapping circles and squares, can be seen as an extension of Wright's work for the Luxfer Prism Company and his graphic illustrations for *The House Beautiful* in 1896. As in his stained-glass windows, Wright varied the width and visual weight of the repoussé patterning to create an interplay between the major panel divisions and the decorative calligraphy within each section.

Constructed out of individual sections soldered into place, each urn varies slightly in its dimensions and shape. Patina is built up out of thin glazes of colored lacquer. Wright intended these urns to appear aged. The four circular medallions, being plaster-filled, give the urn a stability at the same time that they underscore Wright's meticulous attention to details of design.

55.

Table Lamp from the Susan Lawrence Dana House, Springfield Illinois, about 1902–03

Frank Lloyd Wright

Leaded glass and bronze, 24 ¹/₂ x 29 diameter

RECORDED: Hoffmann 1986, p. 65 illus. a similar example

The Susan Lawrence Dana house represents an extensive remodeling of a Victorian house that was virtually obliterated by Wright's new structure. Certainly one of the most lavish of the Prairie houses built by Wright, it is distinguished by the extent to which the architect was able to design both the exterior as well as all the interior fittings, including carpets, curtains, furniture, art glass, and bronze lighting fixtures, such as the example here. The colors of the glass used in the lamp reveal the autumnal palette Wright chose for the house, based on the purple asters, sumac, and goldenrod of the Illinois prairie. This theme was expressed throughout the interior fittings and in the ornamental windows with a stylized sumac motif.

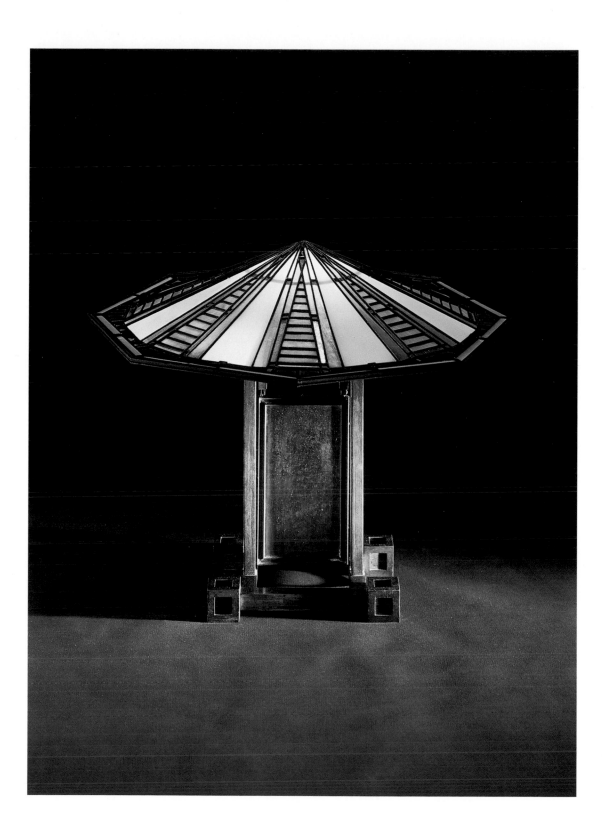

56.

Dining Table with Eight Chairs from the Barton House of the Darwin D. Martin Complex, Buffalo, New York, 1904

Table: oak, 28³/₄ x 60 x 54¹/₂, with two leaves, each 15 x 5¹/₂

Chairs: oak, with leather upholstery, each 46 high

EX COLL.: Mr. and Mrs. George Barton, Buffalo, New York, to William E. Martin, Oak Park, Illinois, descending in the family until 1987

Perhaps one of Frank Lloyd Wright's most fortuitous commissions was that for the William E. Martin house in Oak Park, Illinois, in 1903. Martin, with his brother, Darwin, owned the Martin & Martin Stove Polish Company in Chicago, and his enthusiastic support for the young architect and his work led to a total of nine commissions in Chicago and Buffalo, including the E-Z Stove Polish Factory in Chicago, and culminated in Wright's famous design of 1904–05 for the Larkin Building in Buffalo.

Darwin D. Martin was a principal of the Larkin Company, founded by John Larkin and Elbert Hubbard. By 1895, Hubbard had retired from the company (he was succeeded by Martin) and established the Roycroft Community, which became an important center for the production of Arts & Crafts furniture, metalwork, books, bindings and other decorative objects (cats. 2, 3, 105, 107, 108). Hubbard's sister was married to William B. Heath, the attorney for the Larkin Company. Wright designed homes for the Heaths in Buffalo (cats. 64, 65) as well as for Alexander Davidson, who was brought in by Darwin Martin as advertising manager for the company and later made its treasurer.

With the encouragement of his brother, Darwin Martin commissioned Wright to design a residential complex for his family in Buffalo in 1903. The complex included his own grand house—one of Wright's most important Prairie-style buildings—a garage and conservatory connected to the main house by a pergola, and a smaller house for Martin's sister and her husband, George Barton. The smaller house, fronting on Summit Avenue and perpendicular to the Jewett Parkway axis of the main house and outbuildings, was begun in the fall of 1903, before all other construction. Its design is typical of Wright's smaller Prairie houses, and relates closely to the Walser house in Chicago of the same year (Manson 1958, pp. 138–39).

The interiors and furniture for the Darwin D. Martin house were designed by Wright himself, and their manufacture is well documented. Wright turned to the Matthews Brothers Furniture Company of Milwaukee, which worked on the main house from 1904 through 1905. Since the design of the Barton house was contemporaneous with that of the Darwin Martin buildings on the property, Wright probably employed Matthews Brothers to execute his furniture designs for the smaller house as well.

The dining table and eight chairs that Wright designed for the Barton house derive from earlier furniture he had made for the Husser house (1899) and Willits house (1901) and are closely related to the Dana house table and chairs (1902). The Barton house chairs, like these earlier examples, have Wright's characteristically tall backs with narrow vertical spindles, capped with a single, broad crest rail. The spindles descend to the back stretcher, where they intersect with another, narrower horizontal slat. A thin, horizontal strip of wood wraps continuously around the chair legs and rails at the bottom of the chair seat and the crest rail. The spindle motif, repeated under the tabletop, connects the four massive table legs, which are also embellished with a thin wood banding. The chair's legs and rails, and legs of the Barton house table, are octagonal posts, which give these pieces an architectonic quality.

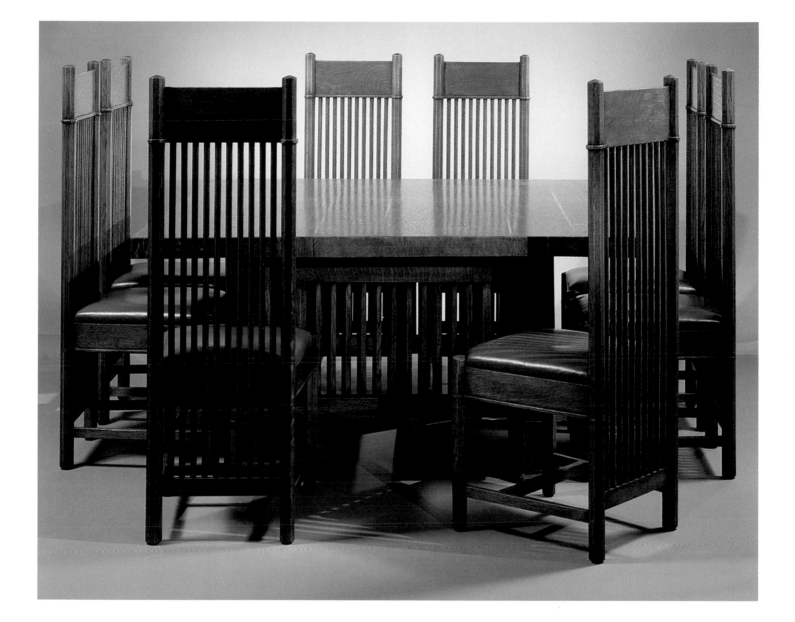

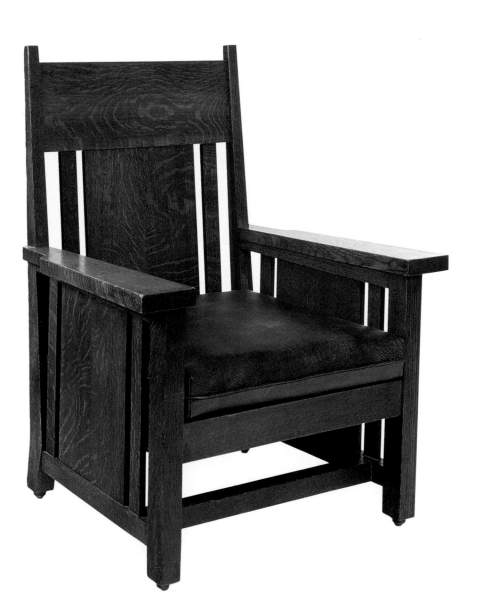

57.

Armchair from the William R. Heath House, Buffalo, New York, 1905

Frank Lloyd Wright

Oak, with leather upholstery,
39$\frac{1}{2}$ x 30$\frac{1}{2}$ x 25$\frac{1}{2}$

RECORDED: Manson 1958, p. 118 illus. an identical example // Gill 1987, p. 147 illus. an identical example

The house Wright designed for the Heaths in 1905 was one of several residences he designed in Buffalo for principals of the Larkin Company, the most famous of which is the Darwin D. Martin house of the same year. The Heath house, more modest in scale than the grand Martin house, was by all accounts an especially cozy and pleasing residence.

This armchair from the living room is typical of the generous yet austere armchairs Wright designed for many of his Prairie houses of this period, including the Bradley house (1900), Willits house (1901) and Dana house (1902). The chair also has an affinity with the designs of Gustav Stickley. In its broad-slat back and sides, wide, flat arms, and forthright construction, it is perfectly in keeping with Arts & Crafts principles.

In the Heath chair, narrow slats on either side of the broad central slat break up the chair back and sides, giving it a varied rhythm distinct from the more straightforward furniture of Stickley and his followers.

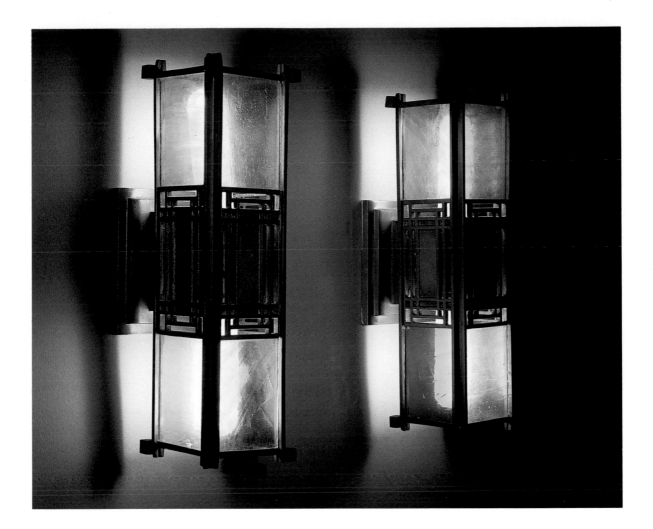

58.

Sconces from the William R. Heath House, Buffalo, New York, 1905

Frank Lloyd Wright

Bronze, with colored glass, each
$13^{1}/_{2}$ x $4^{1}/_{2}$ x $4^{1}/_{2}$

These sconces are a variation on the sconces Wright designed in 1902–04 for the Susan Lawrence Dana house in Springfield, Illinois. The Dana house sconces were gas fixtures, whereas these are electrified. Nearly identical sconces were designed for the Barton house.

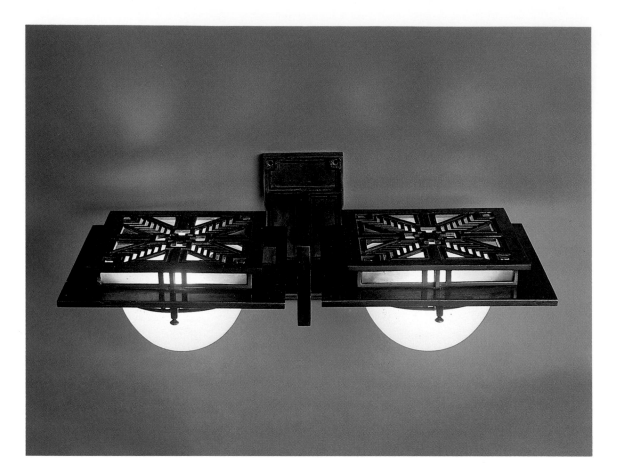

59.

Double-Globed Wall Sconce from the Avery Coonley House, Riverside, Illinois, 1908

Frank Lloyd Wright

Copper, with frosted glass globes and isenglass, $7^1/_4$ x 20 x $11^1/_2$

Light was extremely important in the activation and modulation of Prairie interiors, and Wright was sensitive to the subtle interplay between natural and artificial light and the delicate colors and textures of his rooms. Consequently, one often finds several light sources within the same room, ranging from daylight, filtered through Wright's "shimmering fabrics," and skylights (both naturally and electri-

cally illuminated), to table lamps, chandeliers, and various types of wall sconces.

This double-globed wall sconce originally appeared throughout the first and second floor spaces of the Coonley house, at the crossing of two major axes or to punctuate the end of a sight line. (The single-globed version of this fixture was more common.) Both versions were designed to present an interesting view from either below or above, where the cover plate refers to the fern motif used in the living room ceiling grilles and decorative mural above the fireplace. Similar sconces were later used in the Frederic C. Robie house in Chicago and the Meyer May house in Grand Rapids.

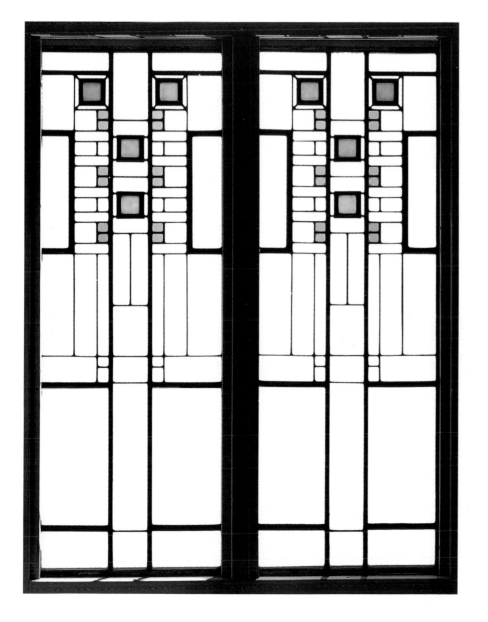

60.

Pair of Leaded-Glass Windows from the Avery Coonley House, Riverside, Illinois, 1908

Frank Lloyd Wright

Clear and colored glass with copper-coated zinc caming, each 44 x 16¹/₄

Wright referred to the Coonley house as "the most successful of my houses" (Manson 1958, p. 187). The Avery Coonleys were exceptionally enlightened clients who wanted the best and most advanced design they could find for their large house in Riverside. With their generous budget, they inspired Wright to create one of the masterpieces of his Prairie house period.

These windows were originally installed on the ground floor of the main Coonley house, facing the private gardens and reflecting pool. Two pairs flanked a pair of leaded-glass doors that opened onto the terrace area. In 1911 Wright modified the entire lower facade of the house by simplifying the area of access to the garden. In the process, however, he removed these windows and the door.

In their design, the windows echo the central motif, which has been described as a stylized floral pattern, of all the glass in the Coonley house. In their reductive geometric composition, these panels are certainly the most abstract. Wright's use of different widths of caming adds to the rhythm of the composition and makes the structural elements of the window itself an integral part of the whole. Although each panel is complete unto itself, additional movement and rhythm are created when the windows are seen side by side, as they were originally installed.

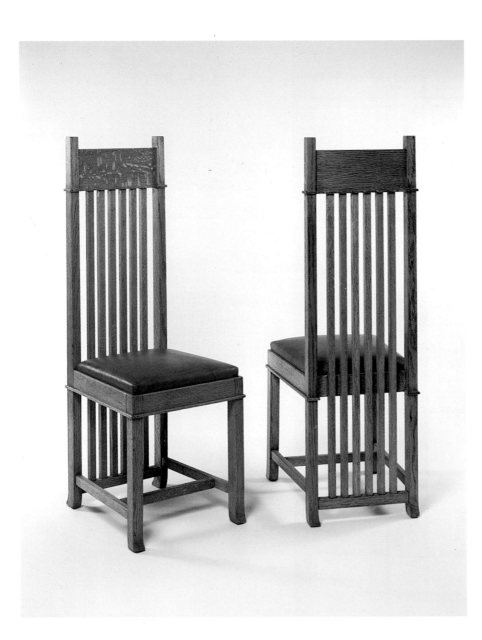

61.

*High-Back Spindle Side Chair from the
Robert W. Evans house, Chicago, Illinois,*
about 1908

Frank Lloyd Wright

Oak, with leather upholstery, each
44¹/₂ x 15 x 17¹/₂

RECORDED: Manson 1958, p. 117
illus. an identical example

EXHIBITED: New Haven 1987,
n.p., lent by Hirschl & Adler Galleries,
New York

The Robert W. Evans house, as is typical
of many of the Prairie houses that Wright
designed in his later Oak Park period
(1905–10), was based on the larger Wil-
lits house of 1901 (Manson 1958,
p. 185).

The chairs that Wright designed for the
dining room of the Evans house, with
their narrow vertical spindles descending
to the bottom stretcher, broad-slat crest
rail, and narrow stripping running around
the bottom crest rail and chair seat, are
similar to his chairs for the Dana house
(1902) and the Barton house (1903–04)
(cat. 56). As in the Dana house chairs, the
back and front feet curve slightly outward.
In the Evans house chairs, the number of
spindles has been reduced by half, giving
the chairs a less complicated look.

These chairs were probably manufactured
by the F.H. Bresler Co. of Milwaukee,
which produced much of the furniture
that Wright designed between 1907 and
1910 under the supervision of the
Niedecken-Walbridge Company (Hanks
1979, p. 44).

62.

Flat Print File from the Thurber Art Gallery, Chicago, about 1909

Frank Lloyd Wright

Oak, 54 x 34 x 26

RECORDED: Storrer 1974, no. 154 illus. in situ // Manson 1958, pp. 167–68.

The Thurber Art Gallery, now demolished, was located in the Fine Arts Building at 410 S. Michigan Avenue in Chicago. Designed in 1909, the gallery was finished shortly before Wright's celebrated sojourn to Europe, which ended his so-called Oak Park period.

The gallery space was subdivided by a series of partitions that housed display cases and built-in print tables, forming a number of alcoves down the length of one side. Natural light came in through two long ceiling panels of leaded glass that ran above the partitions, which housed light fixtures used to illuminate the gallery on cloudy days. (The Thurber leaded-glass panels were similar to those Wright designed for The Studio.) The gallery walls were finished in rough plaster and gilded cork.

The print file is simply constructed, with sixteen slatted drawers that allow air to circulate, each fitted with two square wooden handles within a rectangular cabinet. The overhanging top and simple molding of the cabinet, in addition to giving the piece an architectonic quality, are related to the design of the arcaded partitions of the gallery.

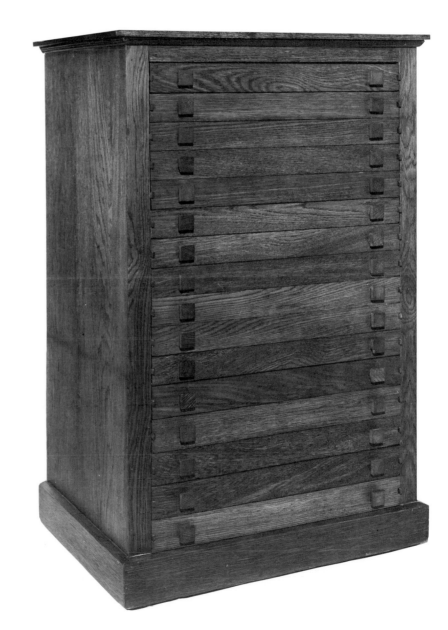

George Mann Niedecken

1878–1945

63.

Design for the Interior of the F.H. Bresler Art Gallery, Milwaukee, about 1904

George Mann Niedecken

Ink, pencil, watercolor, and gouache on paper, 14 x 33

EXHIBITED: Miami Beach 1984, n.p., illus.

George Niedecken described himself as both an architect and interior decorator—an interior architect—and he functioned successfully as an intermediary between architects and clients (Boston 1987, p. 237, no. 97). Worldly and well-read, he was familiar with the European developments of English Arts & Crafts, French Art Nouveau, the Viennese Secession, German Jugendstil, and, closer to home, the work of Frank Lloyd Wright. These major influences forged the basic character of his work.

Niedecken brought a stylistic breadth and diversity to his profession. His approach was eclectic and holistic. He believed in the assimilation of European models to create work that embodied a new American vernacular. To his mind, the interior architect was just the right person to accomplish such an objective, because he not only had taste and vision, but he was an artist at heart: "someone with sufficient knowledge to paint credible pictures ...with training in architecture and modeling; a practical knowledge of the weaving of fabrics and rugs; of the treatment of plaster, wood and all other building or decorative materials which come into the scope of the interior development of buildings" (George M. Niedecken, "Relationship of Decorator, Architect and Client," *The Western Architect*, 19 [May 1913], pp. 42–44).

F.H. Bresler, Niedecken's good friend and business associate, was also a furniture maker, art importer, and print dealer who specialized in American Arts & Crafts objects, Japanese prints, and Chinese ceramics. Not only did Bresler help

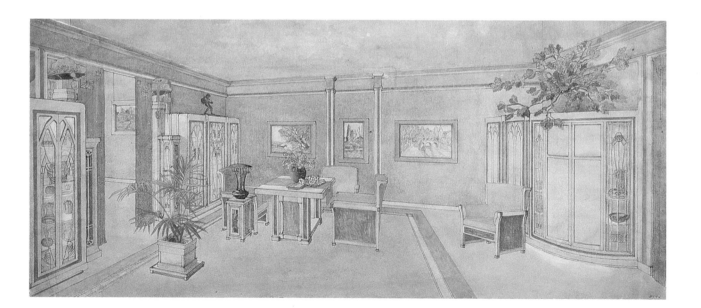

Niedecken produce his first interior design projects, but he was one of the original stockholders of the firm of Niedecken-Walbridge, established in 1907 (Milwaukee 1982, pp. 10 n. 9, 92). In 1904, about the same time he was collaborating with Frank Lloyd Wright, Niedecken designed the showrooms for the Bresler Gallery. The overall character of the gallery, as seen in this drawing, reflects the reductive simplicity of Wright's Prairie style.

Niedecken made highly detailed drawings as a means of presenting ideas to his clients. These works, executed in ink and pencil, with touches of watercolor and gouache, also served as renderings for architects. In this drawing, Niedecken included various examples of American pottery within glass cabinets and landscape paintings on the walls. The interior space of the gallery, redesigned by Niedecken in 1919, was austere and functional, a quintessential Arts & Crafts environment.

64.

Forest Scene (Study for a Mural), about 1907

George Mann Niedecken

Three panels, oil on canvas: two side panels, each $33^{1}/_{2}$ x $51^{1}/_{2}$; center panel, $33^{3}/_{4}$ x $83^{1}/_{8}$ (illus.)

Niedecken received his initial training at the Wisconsin Art Institute (1890–92) as a still life and landscape painter (Milwaukee 1982, pp. 15–26). In some of his earliest drawings and watercolors, executed between 1896 and 1897, he observed and recorded the landscape around his native state of Wisconsin. Landscape remained a central theme in his work. After he returned from a ten-year sojourn in Europe and began exhibiting with the Society of Milwaukee Artists, some of his first works included landscapes and decorative panels. Many of Niedecken's nature studies were translated into monumental, decorative murals. Between 1904 and 1911 he designed and

executed Prairie-style murals for the interiors of a number of private residences, many of which were designed by Frank Lloyd Wright. This painting, with its birch trees in the foreground and lush profusion of flora, was probably intended as study for a mural, perhaps for Wright's Adam Mayer residence in Milwaukee (about 1907).

The Gates Potteries

Terra Cotta, Illinois, 1901–1930

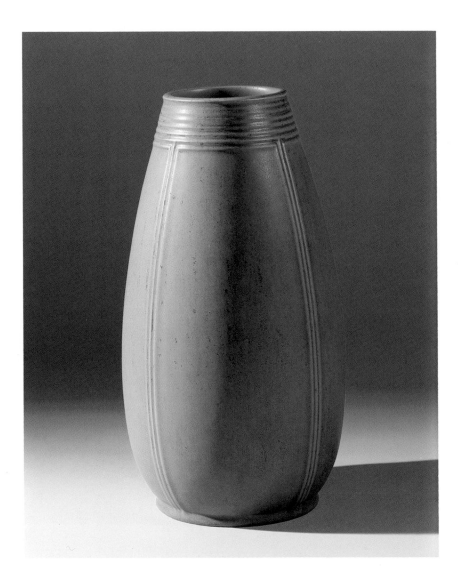

65.

Teco Vase with Classical Motif, about 1903

The Gates Potteries
Hugh Mackie Gordon Garden (1873–1961), designer

Ceramic with matte green glaze, 12 high

Impressed mark (on the bottom): TECO / TECO

RECORDED: Erie 1989, pp. 26, 28 illus. at upper right, 51 no. 252 illus., 52 illus. center right, 124 color pl. 32

In 1901, Gates Potteries, a subsidiary of the American Terra Cotta & Ceramic Company of Terra Cotta, Illinois, added Teco ware to its existing line of tiles and decorative architectural items. Teco—the name derived from a shortening of Terra Cotta—was developed as an exclusive line of affordable art wares cast from molds. The shapes of the vessels, modeled after aquatic plants and classical motifs, also echoed in clay the architectonic forms of the Prairie School. Chicago architects Frank Lloyd Wright, William LeBaron Jenney, and Hugh M. G. Garden contributed designs to Gates Potteries.

This classically inspired vase, designed by Hugh Garden in both 12- and 17-inch heights, was Teco shape 252. The parallel concentric bands running around the top as well as vertically were molded in relief. The smooth Teco Green matte glaze is, according to the company's advertisements, in the "cool, peaceful, healthful" color associated with this ware.

66.

Teco Vase of Round Jardinière Form,
about 1901–20

The Gates Potteries
William J. Dodd (1862–1930), designer

Ceramic with matte green glaze, 9⅝ high

RECORDED: Walter Ellsworth Gray,
"Latter Day Developments in American
Art Pottery II," *Brush and Pencil*, 9 (January 1902), p. 290 illus. an identical example// Eidelberg 1987, p. 79 illus. an
identical example

Collection of Stephen Gray, New York

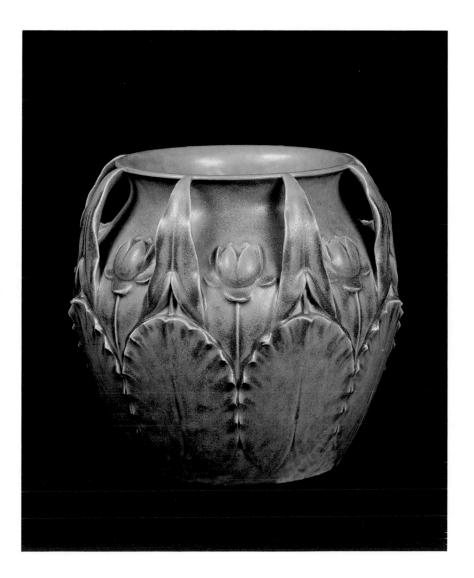

Robert Riddle Jarvie

1865–1941

67.

Three-Branch Candelabrum, about 1903–12

Robert Riddle Jarvie

Brass, 10¼ high

Marked (on the bottom): Jarvie

RECORDED: Darling 1979, pp. 56–57 illus. an identical example

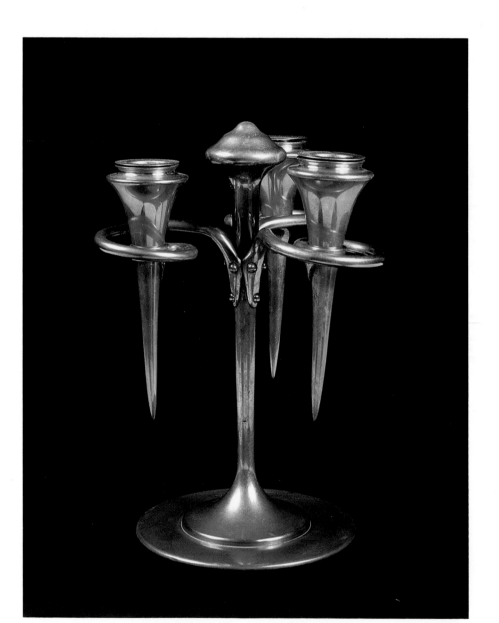

Robert Riddle Jarvie was a self-taught metalsmith employed by the Chicago Department of Transportation at the turn of the century. He first exhibited his work in 1900 at the Chicago Arts & Crafts Society. By 1905 he had left his job with the city and opened The Jarvie Shop. Between 1901 and 1904 Jarvie advertised in *House Beautiful* as "the Candlestick Maker" and was largely supported by the success of his candlesticks, which he exhibited at the Art Institute in 1902. He also designed and produced decorative objects in copper, including bowls, sconces, vases, trays, desk sets, and plates.

After 1912 Jarvie began to attract attention for his gold and silver presentation pieces, which included trophies he designed annually for the Union Stock Yard Company (cat. 70). He was forced to close his shop in 1920; his work remained relatively obscure until the recent revival of interest in the Arts & Crafts Movement, which restored his reputation as one of the preeminent modern American metalworkers.

This candelabrum demonstrates Jarvie's highly sophisticated and imaginative design. The elegant, fluid lines reflect an awareness of Art Nouveau, tempered by a forthright honesty of construction, as in the way rivets secure the arms of the candelabrum to the central stem. The ingenious form of this candelabrum certainly proves Jarvie deserving of the praise he received in *The Craftsman* in 1903: "The graceful outlines and soft lustre of the unembellished metal combine to produce dignity as well as beauty, and the possessor of one of the Jarvie candlesticks must feel that nothing tawdry or frivolous can be placed by its side" (Darling 1979, p. 56).

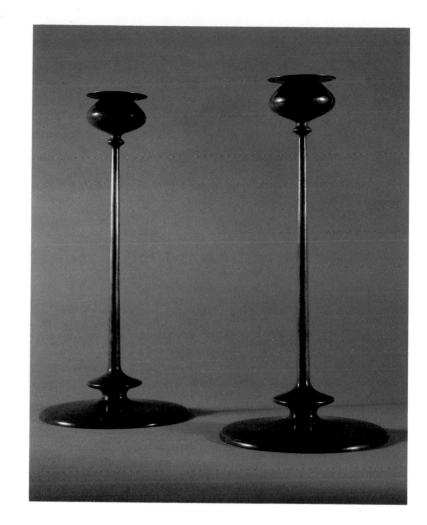

68.

Pair of "Beta" Candlesticks, about 1904

Robert Riddle Jarvie

Cast bronze, 12 1/2 high

Marked (on the bottom): Jarvie/B(eta)

Robust and sculptural, this Beta design was exhibited by Jarvie in the 1904 Louisiana Purchase Exposition in St. Louis. Arguably the most popular of Jarvie's candlestick designs, it was widely copied in the period, although none of the reproductions had the exquisite proportions and grace of the original.

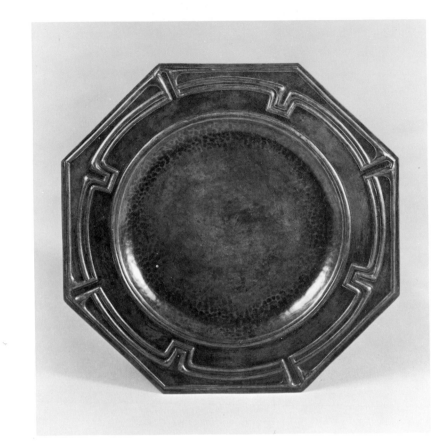

69.

Plate, about 1910

Robert Riddle Jarvie

Copper, 9¹/₄ diameter
Marked (on the bottom): Jarvie

Jarvie achieved in his work a synthesis of
the medieval revival aesthetic, found
throughout the Arts & Crafts Movement,
and an astute understanding of the princi-
ples of Art Nouveau design. In its hand-
hammered surface and repoussé decora-
tion, this plate not only well represents
Jarvie's approach to design, but also shows
his affinity with the other important
Chicago metalwork firm of the Arts &
Crafts period, the Kalo Shop. It relates as
well to the copper objects designed by
Frank Lloyd Wright after the turn of the
century, especially his large urn (cat. 54),
originally made in 1899 for the Waller
house, and used frequently thereafter.
In their surfaces and strikingly similar
repoussé decoration, these works show the
pervasive influence of the Arts & Crafts
aesthetic in Chicago.

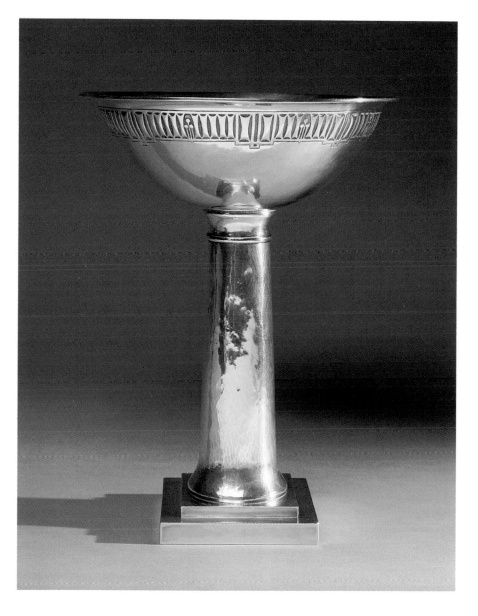

70.

Commemorative Trophy, 1916

Robert Riddle Jarvie

Sterling silver, 11 1/4 x 8 1/2 diameter
Marked and inscribed (underneath):
STERLING Jarvie 1140; PRE-
SENTED TO/THE UNIVERSITY OF
ILLINOIS/FOR ITS AGRICUL-
TURAL EDUCATIONAL DISPLAY/
INTERNATIONAL LIVESTOCK
EXPOSITION 1916

Beginning in 1912, Jarvie listed himself in the Chicago telephone directory as a silversmith. About this time he also moved his workshop to the second floor of the Chicago stockyards. Arthur G. Leonard, then the president of the Union Stock Yard Company, commissioned Jarvie to design and produce a series of trophies and decorative awards, which would be given out as prizes at the various livestock fairs in Chicago and neighboring states.

These trophies represent some of Jarvie's best work, and many Prairie architects, including George Grant Elmslie, had him execute other commemorative designs, such as a loving cup for James B. Angell on his retirement as president of the University of Michigan. Jarvie's close relationship with Elmslie, no doubt based on the fact that Elmslie's wife worked in Jarvie's shop, was reciprocated when Jarvie asked the architect to help him design a commemorative box for the American Meat Packers Association.

The present commemorative trophy was given to the University of Illinois at the 1916 Livestock Exposition. Rising from a stepped base, the gently tapering shaft is lightly planished, giving it a subtle texture and brilliance. The bowl bears geometric designs rendered in repoussé that are reminiscent of Elmslie's architectural fretwork and his designs for the AMPA box. The inscription on the bottom of the trophy's base indicates that the piece was designed and produced especially for the fair and later inscribed to the winner.

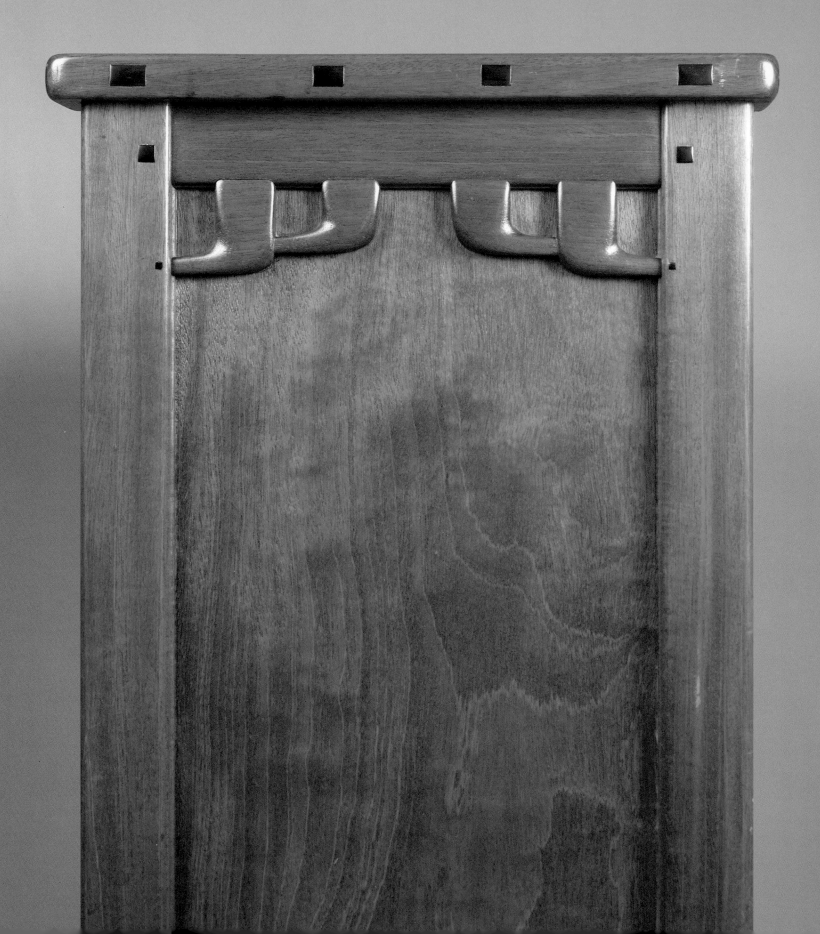

The West Coast

Along the Arroyo Seco of Pasadena, in the decade prior to World War I, the brothers Charles and Henry Greene designed and built a number of homes, including several lavish residences for wealthy clients who had moved to the new paradise of southern California, where the concept of a winter residence was giving way to that of year-round living. Themselves natives of the Midwest, born in Cincinnati and raised largely in St. Louis, the Greene brothers had followed their parents to Pasadena in 1893. En route, they visited the World's Columbian Exposition in Chicago and had been greatly impressed with the Ho-o-den exhibit of the Japanese government, which replicated a traditional temple near Kyoto and was a source of inspiration for Frank Lloyd Wright as well.

Around 1901, after several years of designing rather undistinguished buildings, the Greene brothers' work underwent a dramatic change. Along with Oriental design, they embraced the Arts & Crafts style and philosophy, beginning perhaps with Charles' wedding trip to England, where he may have seen the work of the British Arts & Crafts Movement. The brothers certainly encountered Arts & Crafts in *International Studio*, Stickley's *The Craftsman*, and through the publication of other architects' work, such as Will Bradley's interiors and furniture for *Ladies Home Journal*, clipped and added by Charles Greene to his scrapbook (Makinson 1977, p. 19).

The Greene brothers proceeded to build in and around Pasadena and Los Angeles a type of home that became known as the California Bungalow, the most impressive examples of which are the Blacker and Gamble houses of 1907–09 in Pasadena, and the Pratt and Thorsen houses farther north, which Makinson has called the "ultimate bungalows." These magnificent dwellings, blending the Arts & Crafts emphasis on materials with the sensibility of the Orient and the simplicity of the local Franciscan missions, confirmed the Greene brothers' reputation as Arts & Crafts architects without peer.

The Greenes' style naturally exploited the mild climate of southern California, making use of generous sleeping porches sheltered by wide, overhanging roofs that were supported by shaped beams projecting beyond the roof line. There were also terraces which, in the Gamble house, overlooked the Arroyo. By opening the inside of the house to the surrounding landscaped gardens and pools, these terraces helped to connect the man-made environment to the natural landscape beyond.

But it was inside the homes, in the exquisite handling of the cabinetry and furniture, that the Greenes achieved the work that was to become their hallmark. In contrast to the straight

Charles Summer Greene and Henry Mather Greene
Vitrine, Blacker house (detail). CAT. 75

lines and forthright detail characteristic of Stickley's furniture, their designs incorporate smooth rounded edges, elaborately pegged joints, sometimes intricate inlay, and a sinuous line as reflective of Art Nouveau as of the more traditional Craftsman style.

The Greenes' first great patron was Adelaide Tichenor, for whom they built their initial Craftsman Bungalow in Long Beach in 1904 (cats. 79, 80). Having attended the Louisiana Purchase Exposition, Mrs. Tichenor insisted that Charles make a visit as well, to see the designs of Gustav Stickley, Charles Limbert, William Grueby, and others practicing the Arts & Crafts style. At the fair, Charles purchased several Grueby pots for the Tichenor home. The Greenes had included Stickley furniture in several of their earlier residences, but after 1904 they designed more and more of the furniture and fixtures for the homes they built. This practice could prove exasperating to their clients, including Mrs. Tichenor, who at one point in the lengthy construction of her home complained to the Greenes: "Can you leave your Pasadena customers long enough so that I may hope to have my house during my lifetime? Do you wish me to make a will telling who is to have the house if it is finished?" (quoted in Makinson 1977, p. 99).

The sensuous, languorous quality of California life, already evident at the turn of the century, influenced the architecture not only of the Greenes, but also of their contemporaries Irving Gill, in the south, and Bernard Maybeck, in the north. It found expression in the decorative arts as well. In San Francisco, Arthur and Lucia Kleinhans Mathews founded The Furniture Shop in 1906, when the great earthquake provided a wealth of opportunities for architects and designers in the area. Arthur Mathews was a painter and mural designer and director of the California School of Design in addition to creating his own furniture and decorative objects, which often boasted elaborately carved, painted, and gilded surfaces.

Dirk Van Erp, a Dutch coppersmith who found work in the San Francisco shipyards, opened his well-known shop in Oakland in 1908. He soon had a wide following for his riveted copper lamps with mica shades and other decorative accessories in copper, finished with a characteristically hand-hammered surface. When he joined the war effort in 1916, he left the shop in the care of his son and daughter and Harry St. John Dixon (the younger brother of the painter Maynard Dixon). Dixon had apprenticed under Van Erp and was soon making metalwares under his own shopmark.

Although the great center of Arts & Crafts pottery was in the Midwest, Frederick Hurten Rhead, who had designed ceramics for Roseville and Weller potteries in Ohio, moved to California in 1911 and established the Arequipa Pottery in Fairfax, where it functioned as therapeutic activity for the patients of the Arequipa Tuberculosis Sanitarium. The most prominent among the California ceramicists, and perhaps the most prodigious, Rhead later opened his own pottery in Santa Barbara; the fluid lines of his landscape abstractions with incised outlines again reflect the pastoral California sensibility. The peripatetic Rhead ended his career with the Homer Laughlin China Company in Ohio, where, in keeping with the Arts & Crafts philosophy of fostering good design for moderate prices, he was responsible for the design of Fiesta Ware in 1935, now seen as a classic of American mass-market design.

Perhaps more than in other sectors of the United States, the expressions of the California Arts & Crafts Movement were influenced by the landscape, climate, and geography of their region. It was the great achievement of the Arts & Crafts style in California to have fostered the impeccably detailed, Japanese-influenced bungalows of the Greene brothers as well as Bernard Maybeck's more modest, shingled, Swiss-chalet bungalows without relinquishing any of the founding principles of the movement. One need only step inside the Gamble house to see at once California's vaunted eclecticism, here already at work at the beginning of the century.

ANN YAFFE PHILLIPS

Charles Sumner Greene

1868–1957

Henry Mather Greene

1870–1954

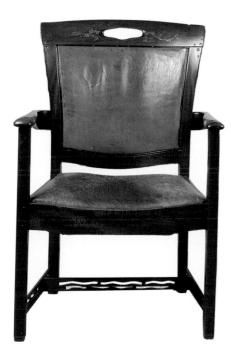

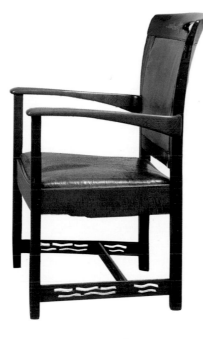

71.

Pair of Living Room Armchairs from the Charles M. Pratt House, Ojai, California, about 1909

Charles Sumner Greene
Henry Mather Greene

Mahogany and ebony, with inlaid fruitwood and original leather upholstery, each 35¹/₄ x 23³/₈ x 18³/₄

Marked with brand (inside rail behind cushion): Sumner Greene/His True Mark

RECORDED: Makinson 1979, pp. 95 illus. in situ, 97 illus.

Along with the Blacker (see p. 108), Ford, and Gamble houses in Pasadena, and the Thorsen house in Berkeley, the Charles M. Pratt house, in Ojai Valley, was considered one of Greene and Greene's ultimate bungalows.

This pair of living-room armchairs is distinguished by their gently curving arms, pierced crest rails and stretchers. The subtle use of fruitwood inlay on the crest rails, recalling a gnarled fruit-laden tree inspired by a California white oak, and of leather back rests enframed by thin stripes of ebony are painterly touches that not only reflect the architects' concern for craftsmanship, but also their sensitivity to Japanese influence.

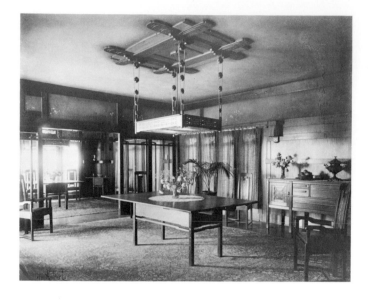

Charles Sumner Greene and Henry Mather Greene, *Dining Room*, Blacker house, 1907–09

72.

Table and Six Chairs from the Dining Room of the Robert R. Blacker House, Pasadena, California, 1907–09

Charles Sumner Greene
Henry Mather Greene

Table: mahogany and ebony, with copper, pewter, and mother-of-pearl inlay, $81^{14}/_{16}$ x $51^{3}/_{4}$ x $29^{3}/_{4}$; with four leaves, each $51^{1}/_{2}$ x $11^{1}/_{4}$ x $^{3}/_{4}$

Chairs: mahogany and ebony, with copper, pewter, mother-of-pearl inlay, and leather upholstery, each about 42 x $17^{3}/_{4}$ x $17^{3}/_{4}$

RECORDED: Makinson 1977, pp. 150–55, 154 illus. an identical example in situ

According to Makinson (1977, pp. 150–55), between 1907 and 1911 Greene and Greene conceived seven designs for houses that achieved "such a high level of craftsmanship and design sophistication that they have rarely been equalled. As a result, these houses, among the finest examples of the Arts and Crafts Movement in America, may be properly identified as the 'ultimate bungalow.' The first of these masterpieces was the Robert R.

Blacker House, which was built on the most prestigious site of the Pasadena's Oak Knoll subdivision."

This dining room table and set of six dining room chairs, the sideboard (cat. 74), vitrine (cat. 75), and armchair (cat. 73)—one of a set of about ten chairs that had two arms—have the same material components and fine detailing that distinguished the interiors of the Blacker house, paneled as it was in teak and mahogany with peg detailing in ebony and mahogany. The use of mother-of-pearl inlay in passages of the sideboard and table are painterly touches that characterize Greene and Greene designs and reflect the architects' sensitivity to Japanese influence. By 1907 the brothers Greene employed the Peter Hall Manufacturing Company, Pasadena, for the production of their furniture. In the mill, Charles Greene worked closely with master craftsmen, particularly Peter Hall's brother, John. The consistent quality and historical significance of Greene and Greene furniture is due not only to the architects' innovative design but to their vigilant supervision of production and rapport with the fabricators.

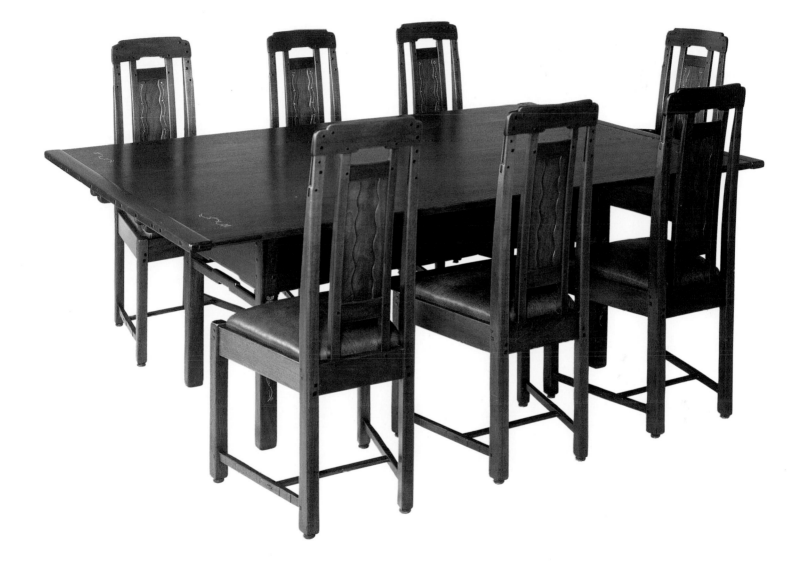

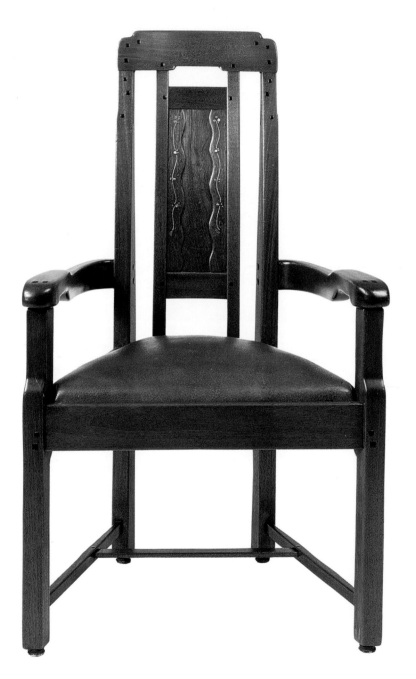

73.

Pair of Armchairs from the Robert R. Blacker House, Pasadena, California, 1907–09

Charles Sumner Greene
Henry Mather Greene

Mahogany and ebony, with leather upholstery, each 42 x 24³/₄ x 18
Marked (on chair frame and seat): II

RECORDED: Makinson 1977, pp. 150–55, 154 illus. an identical example in situ

EXHIBITED: New York 1986, p. 52 no. 44 illus. in color

One chair lent by Rosemary and George Lois

Sideboard from the Robert R. Blacker House, Pasadena, California, 1907–09

Charles Sumner Greene
Henry Mather Greene

Mahogany and ebony, with copper, pewter, and mother-of-pearl inlay, 38$^1/_8$ x 95$^1/_4$ x 22$^1/_4$

RECORDED: Makinson 1977, pp. 150–55, 154 illus. an identical example in situ

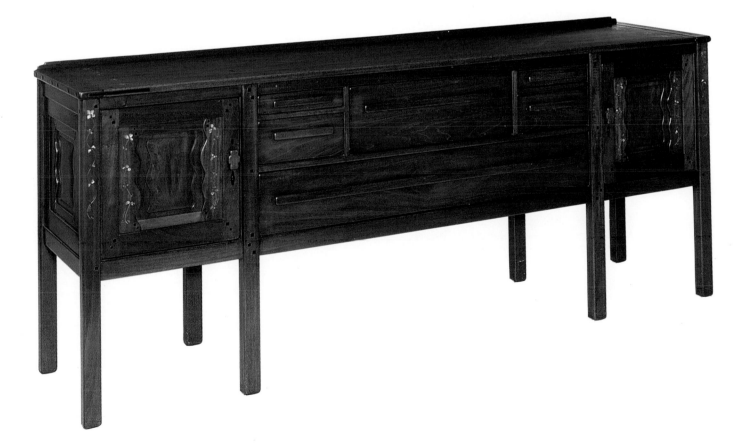

75.

*Vitrine from the Living Room of the
Robert R. Blacker House, Pasadena,
California*, 1907–09

Charles Sumner Greene
Henry Mather Greene

Mahogany and ebony, 56½ x 66 x 22

RECORDED: Makinson 1979, pp. 56–
67, 58–60 illus. // Boston 1987, p. 403
illus. in situ

EXHIBITED: New York 1986, p. 53
no. 45 illus. in color

The "cloud-lift" motif in the upper right-
and left-hand corners of this vitrine was
repeated in other pieces of living room
furniture. The use of "dancing" square
ebony peg joinery became the Greenes'
signature during this important period.

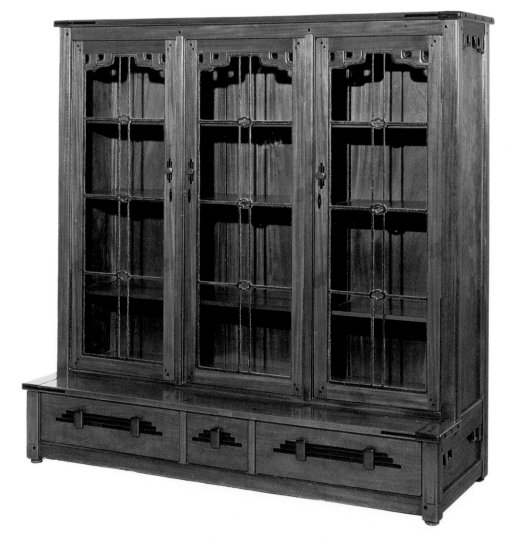

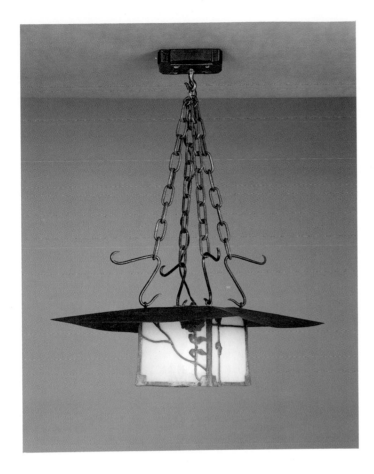

Charles Sumner Greene and Henry Mather
Greene, *Dining Room*, Jennie A. Reeve house,
1904. Courtesy, Documents Collection, College
of Environmental Design, U.C.B.

76.

*Lantern from the Dining Room of the
Jennie A. Reeve House, Long Beach,
California*, about 1904

Charles Sumner Greene
Henry Mather Greene

Copper and leaded glass: lantern,
7 x 7 x 7; shade, 18 x 18

RECORDED: Makinson 1977, pp. 82–
83, 84 illus. an identical example in situ,
85 // Makinson 1979, pp. 22, 23–24
illus. an identical example in situ, 25

According to Makinson (1977, p. 82), in
their design for the Jennie A. Reeve house,
"Greene and Greene brought together
most of the architectural elements that
would become readily identified with their
own unique vocabulary. It is the pivotal
structure in their embrace of the Arts and
Crafts Movement. The two-story, single-
clad bungalow contained the Greenes'
characteristic articulated timber structure,
multiple-gabled, deeply overhanging roofs
(with the projecting support beams now
shaped on the ends), open sleeping
porches, vertical slit windows for closet
ventilation, horizontal bands of casement
windows, a sensitive combination of boul-
der and cobblestone with clinker brick
masonry, Tiffany glass designs in doors,
windows and lighting fixtures, and the
coordination of landscape, walks, fencing
and garden gates." Here, in an elegant
architectural statement, was a prototype
for their concept of holistic design.

In the interior of the Reeve house, lighting
and light fixtures were given special atten-
tion. The architects designed hanging and
bracketed lanterns of Tiffany glass with
vine-patterned leaded overlay capped by
broad canopies that recalled Oriental
lanterns. Originally, a lantern such as this
one was suspended from the ceiling by
chains; others were fastened to wall
brackets and were complemented by
gaslight jets in case of a power failure.
These fixtures appeared in the living and
dining rooms. This lantern comes with its
original chain and ceiling bracket.

Charles Sumner Greene and Henry Mather
Greene, *Living Room*, Blacker house, 1907–09

77.

*Lantern from the Living Room of the
Robert R. Blacker House, Pasadena,
California*, about 1907–09

Charles Sumner Greene
Henry Mather Greene

Mahogany and stained glass, 28 1/2 x
25 1/2 diameter

RECORDED: Makinson 1979, pp. 58–
59 illus. an identical example in situ, 100
illus. an identical example // Boston 1987,
p. 403 illus. an identical example in situ

Each Greene and Greene commission
inspired new designs for light and lighting
fixtures. Within the same house, variance
rather than uniformity was the norm. In
the Blacker house, for instance, as one
moves from the entry hall into the living
room, dining room, or downstairs bed-
room, the character of the fixtures
changes.

Always looking for new ways to introduce
modern electricity through elegantly
crafted fixtures, Charles Greene's designs
were carried out with leaded, stained

Tiffany glass and fabricated by the work-
shop of Emile Lange, a leaded-glass
artisan who worked closely with the
architect. Glass panels were usually placed
into wooden or metal frames, which were
either affixed to the wall or hung from the
ceiling with leather straps or metal rods.
The amount and intensity of illumination
varied according to the thickness and
opacity of the glass used.

In one of the architects' preliminary draw-
ings of furniture for the Blacker house
living room (Makinson 1979, p. 58), this
octagonal lantern appears along with
tables, cabinets, sideboards, and chairs. In
a vintage photograph taken of the original
living room (reproduced here), the same
fixture and about five others appear sus-
pended from a square teakwood ceiling
plate by two sets of wires. The glass used
in each of these lanterns carries water lily
motifs that were intended to echo the lily
pond built in the back garden. The pond,
part of the original six-acre plot, was later
drained when the land was subdivided
and sold.

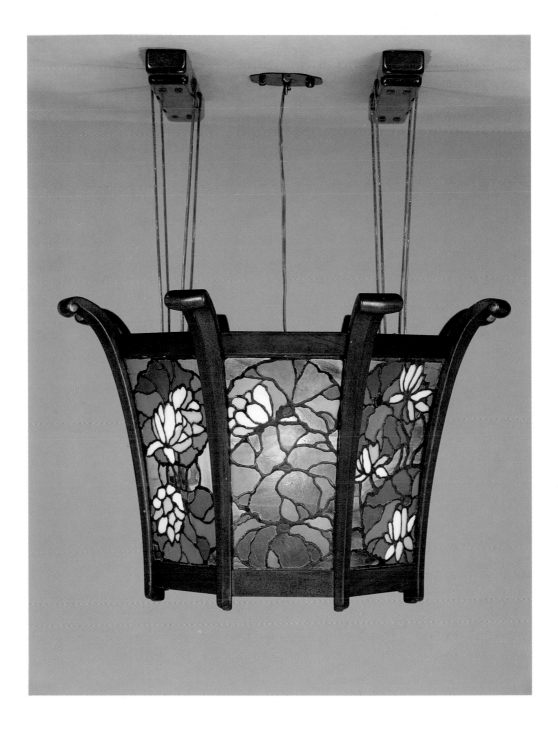

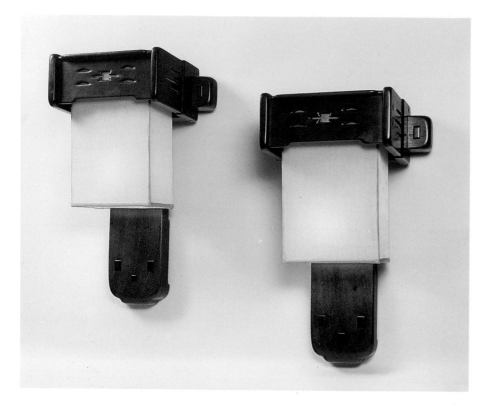

78.

Pair of Wall Sconces from the Dining Room of the Robert R. Blacker House, Pasadena, California, about 1907–09

Charles Sumner Greene
Henry Mather Greene

Mahogany, ebony pegs, and glass, each 18 1/2 x 11 3/4 x 7 1/4

RECORDED: Makinson 1977, p. 154 illus. an identical example in situ

This pair of wall sconces was designed to provide ambient light in the dining room on the main floor of the Blacker house. Like most of the furniture designed by Greene and Greene, these fixtures were produced by the workshops of Peter Hall and Emile Lange. They are a basic T-form pierced at the top, inset with bits of colored glass, and fitted with yellow opalescent glass panels having pendant rectangular silk shades.

Harry St. John Dixon

1890–1967

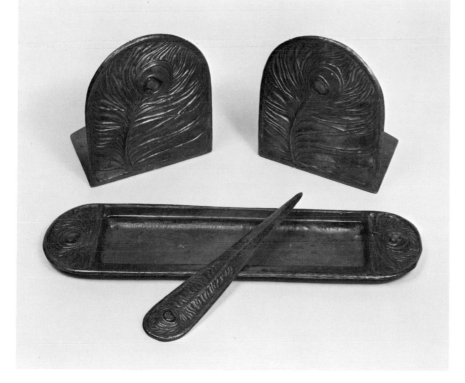

79.

Desk Set, about 1915

Harry St. John Dixon

Painted copper, painted and encrusted
enamels: pair of bookends, each 5⅝
x 5⅛ x 4½; pen tray, ⅝ x 13¼ x
3¹³/₁₆; paper knife, 8¹/₁₆ x 1⁹/₆ x ¼

Each piece stamped (on the back):
HDIXON/San Francisco

RECORDED: Boston 1987, pp. 276
no. 138 illus., 277

Harry Dixon, younger brother of the
painter Maynard Dixon, became an
apprentice to Dirk Van Erp at the age of
eighteen. He worked with Van Erp and
other craft shops in the San Francisco Bay
Area and opened his own shop about
1921–22. At this time he began signing
his metalwares with the punchmark (a
man forging a bowl) designed by his
brother. During the Arts & Crafts period
it was common practice for craftsmen to
appropriate motifs illustrated in various
trade journals and international publica-
tions and to integrate them into their own
designs. The quintessentially Art Nouveau
peacock motif of this desk set was proba-
bly taken from an illustration of a
repoussé finger plate (or push plate for a
door) in copper and enamel by the English
craftsman C.E. Thompson, published in
The International Studio in 1902. Dixon
believed that a particular material should
be compatible with an object's design and
function. In this case, the pliability and
texture of copper make it perfectly suited
for the patination and design of this
desk set.

Rhead Pottery

Santa Barbara, California, 1913–1917

80.

California Landscape Vase, about 1914

Frederick Hurten Rhead (1880–1942),
designer

Ceramic with green and blue glazes, 11 1/2
high
Impressed mark (on the bottom): [Rhead
Pottery]

Frederick Hurten Rhead was born in
Staffordshire, England, the descendant of
several generations of distinguished pot-
ters. He spent his formative years in the
ceramics field at various Staffordshire
potteries. In 1902, he immigrated to
America and was soon established at
Vance/Avon Faience company as design
director. Later he acted in a similar capac-
ity at Weller, Roseville, and Jervis potter-
ies. He was a frequent contributor to
Keramic Studio and was associated with
the magazine's editor, Adelaide Alsop
Robineau, at University City pottery from
1909 to 1911.

In 1911, Rhead moved to California and
founded the Arequipa Pottery in Fairfax.
His staff consisted of patients of the Are-
quipa Tuberculosis Sanitarium. Two years
later, he established his own studio in
Santa Barbara, which lasted only four
years. Rhead provided a host of assistants
with vessel shapes, glazes, and ornamental
designs; fine embellishments were always
applied by hand.

Rhead is renowned for his incised outlines
and sensual arabesques. His friezelike
designs often evoke California landscapes,
transposed into undulating and organic
shapes reminiscent of European Art Nou-
veau. Through the addition of muted
glazes in this vase, Rhead achieved a new
level of refinement.

Rhead spent the last decades of his career
in commercial ceramic production, first
with American Encaustic Tiling Company
(1917–1927) and finally with Homer
Laughlin China Company (1927–1942),
where he was responsible for the design of
Fiesta Ware. During his long and varied
career, Rhead greatly influenced American
art pottery both through his writings and
his synthesis of English ceramic tech-
niques, Art Nouveau, and indigenous
American designs.

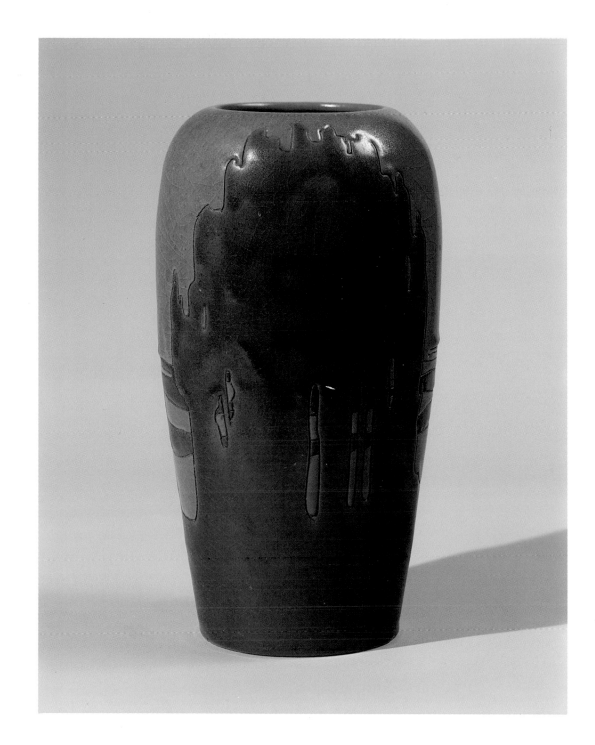

Dirk Van Erp

1859–1933

81.

Table Lamp, about 1910

Dirk Van Erp

Copper, with mica shade, 25 x 23
diameter
Impressed mark (on the bottom): D'Arcy
Gaw/Dirk Van Erp [within closed box
under windmill]

RECORDED: The Dirk Van Erp Archives,
The Oakland Museum, California,
photograph of an identical lamp in situ

Dirk Van Erp came from Leeuwarden,
Holland, to America in 1886, and eventu-
ally found work as a coppersmith in the
San Francisco shipyards. He began to
make decorative objects from shell casings
and, with some public interest and sales,
opened his own shop in 1908. In 1910 he
went into partnership with the designer
D'Arcy Gaw, who apparently was respon-
sible for designing several early mica-
shade lamps, a form Van Erp had initiated
earlier (Pasadena 1974, p. 80).

Van Erp and Gaw terminated their part-
nership in 1911, at which time Gaw's
name was removed from the shopmark.
As a result the mark was weakened, and
the right side of the box enclosing the Van
Erp name fell off, it is thought, around

1912. This provides a convenient means
to date objects from the Van Erp shop.
Later, around 1915, the words "San
Francisco" were added beneath the box,
possibly in response to the Panama-Pacific
Exposition held that year, which gave a
new cachet to works made in the area.
Van Erp retired in 1929 and left the shop
to his son, William, who lived into the
1970s.

Although a variety of decorative copper
objects were made by the Van Erp shop—
vases, planters, bowls, and accessories—
the copper electric lamps with mica shades
are notable among Arts & Crafts metal-
work for their material integrity and
handcrafted facture.

This particular lamp is noteworthy for its
tall, articulated cap and double copper
shade straps; both details are not com-
monly found in Van Erp lamps. The dou-
ble straps and the decorative use of rivets
reinforce the allusion to medieval metal-
work. The bold form of the copper base
and the generous spread of the shade,
matched by the sinuous curve of the arms
supporting the shade, make this lamp a
remarkable combination of strength in
form and finesse in detailing.

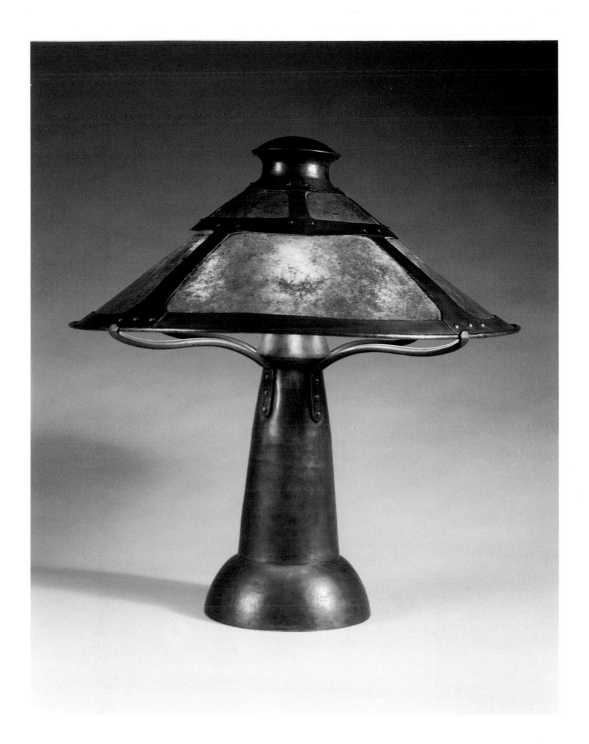

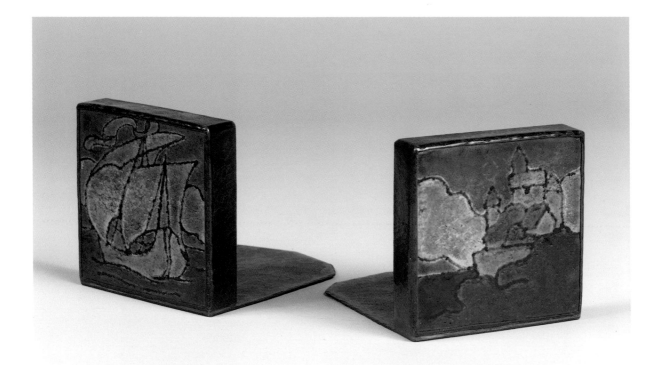

82.

Set of Bookends with Grueby Tiles, about 1910

Dirk Van Erp

Copper and glazed ceramic, 4¹/8 high
Impressed mark (on the bottom): D'Arcy
Gaw/Dirk Van Erp [within closed box
under windmill]

The shopmark on these bookends dates
from the early years of the Van Erp shop,
when he was in partnership with the
designer D'Arcy Gaw. It is thought that
D'Arcy Gaw not only designed some of
the more important Van Erp copper and
mica lamps of the period, but also other
decorative objects, such as these book-
ends. Works produced by the shop which
incorporate Grueby tiles are rare, and it is
possible that these bookends were custom
made, perhaps for Miss Gaw's personal
use.

83.

Humidor, about 1911–15

Dirk Van Erp

Copper, with tin interior, 7 1/2 x 4 3/8 diameter

Impressed mark (on the bottom): D I R K V A N E R P [within closed box below windmill]

EX COLL.: private collection, Oakland, California

Although known for his copper lamps with mica shades, Dirk Van Erp also produced a variety of objects in copper, including planters, bowls, vases, and accessories. Smoking accoutrements, such as this humidor, are not as common.

Made with a poured-tin interior to accommodate tobacco, it has a separate interior lid with a soldered handle. The outer copper sheath was probably finished after the interior was poured. The rich, reddish patina and hand-hammered surface are characteristics of the Van Erp shop.

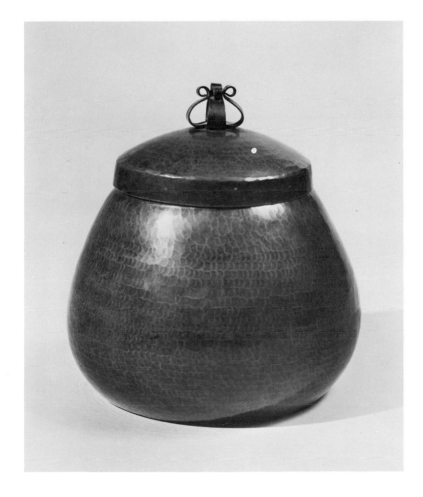

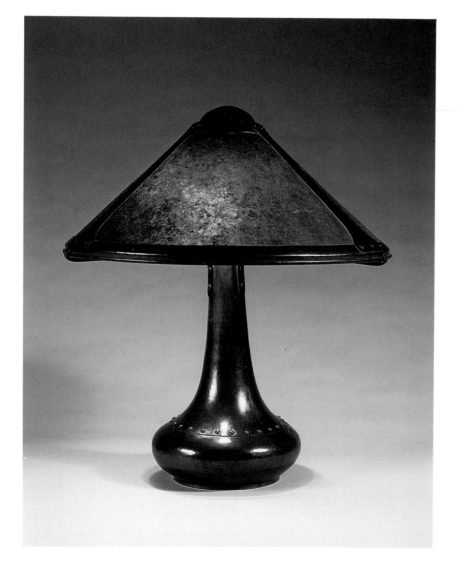

84.

Table Lamp, about 1912–15

Dirk Van Erp

Copper, with mica shade, 22 high
Impressed mark (on the bottom): DIRK
VAN ERP [within box below windmill]

EX COLL.: the artist; to private collection, San Francisco; by descent in the family, until 1987

RECORDED: Princeton 1972, p. 90 fig. 118 illus. an identical example

This trumpet base is one of the more typical forms for the Van Erp copper and mica-shade lamps. This example has three riveted battens holding the four mica sections that form the conical shade. The shade is held by three straight copper arms which extend from the base of the lamp and are attached to it with hand-wrought screws.

85.

Table Lamp, about 1915–27

Dirk Van Erp

Copper, with mica shade, 17 1/2 x 18 1/2 diameter

Impressed mark (on the bottom): D I R K V A N E R P [within broken box with right corner missing, below windmill]/S A N F R A N C I S C O

EX COLL.: Marion Elizabeth Brown and Jean Williamson, Berkeley, California, until 1984–85; private collection, San Francisco

The red warty finish usually found in Van Erp vases occurs very rarely in a lamp. Noted for its rich and irregular surface, the finish derives from the forging process, when the heating, soldering, and hammering of the object into its final shape changes the color of the copper sheet to the reddish tones seen here. Although Van Erp liked this more rustic look, he infrequently left objects in this state. Occasionally, however, he saw the rough hammering and red color as particularly appropriate to a piece, and it was left in this form rather than being given a final hammering and finishing.

Given the scarcity of works in the red warty finish, and the fact that these pieces rarely appeared on the commercial market, it seems likely that this lamp would have been acquired by someone who knew Van Erp personally or was acquainted with an employee of the shop. It was originally owned by Marion Elizabeth Brown who along with her relative, Jean Williamson, shared an Arts & Crafts house in Berkeley designed by Bernard Maybeck. They knew Van Erp, as well as his son, William, and bought many decorative objects from the shop. Their library of books and ephemera relating to California now resides, in part, in the California Historical Society.

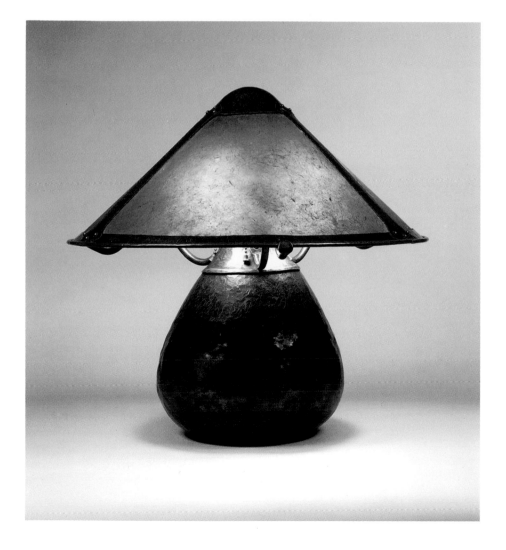

86.

Vase, about 1915

Dirk Van Erp

Copper, 13 ¹/₄ x 7 ¹/₂ diameter (variable)
Impressed mark (on the bottom): DIRK
VAN ERP [within box with right border
missing, below windmill]/SAN FRAN-
CISCO

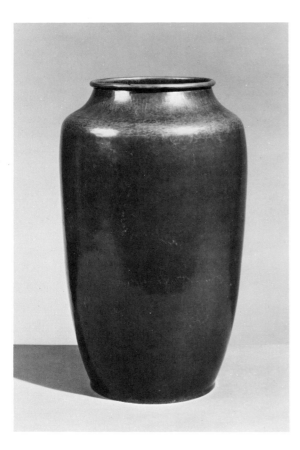

Albert Berry

1878–1949

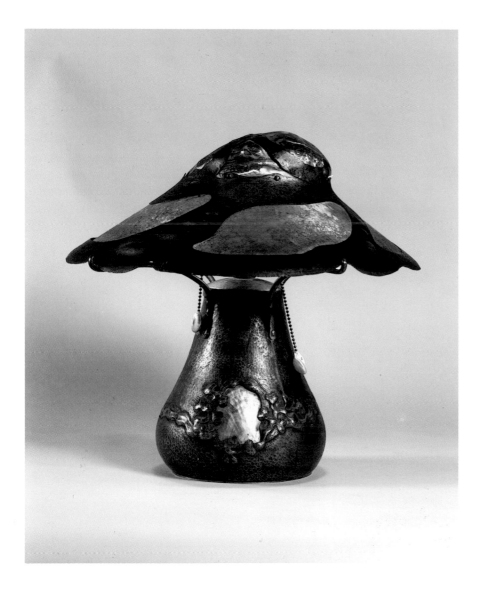

87.

Copper Table Lamp with Shade of Copper, Mica, and Abalone Shell, about 1918

Albert Berry

Hammered copper, mica, abalone shell, and two copper chains with shell pulls, 15 1/2 high
Impressed mark (on the bottom): BERRY ['] S / THEIR MARK / CRAFT SHOP / SEATTLE [encircling a metalsmith's hammer to which a large initial B is affixed]

Although Albert Berry exhibited only once with The Society of Arts and Crafts, Boston, in 1899, it is still possible to glean information about his early life from the exhibition catalogue. Berry was listed as a silverware designer, whose address was the Rhode Island School of Design in Providence. Subsequently, Berry lived in Alaska. In 1918 he relocated to Seattle, where he established Albert Berry's Craft Shop.

This lamp is characteristic of Berry's Arts & Crafts style, with its imaginative hand-wrought designs that incorporate various natural materials and textures into the copper. Besides copper, mica, and shell, as in this example, Berry also combined fossilized walrus tusks with hammered copper.

The organic, undulating lines of this lamp recall French Art Nouveau and German Jugendstil. The stylized plant and human forms and the amalgamation of materials parallels the experiments with mixed media carried out by Louis Comfort Tiffany, whose work was exhibited at The Society of Arts and Crafts, Boston, in 1897 and 1899.

Berry took pride in the handcrafted aspect of all the wares sold at his shop. In addition to the custom-made items, the shop also carried American Indian baskets and textiles.

Arthur F. Mathews

1860–1945

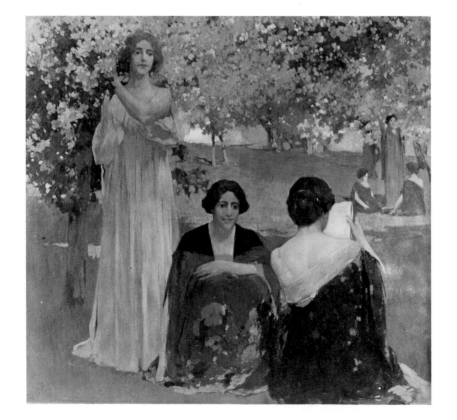

88.

Ladies on the Grass, about 1915

Arthur F. Mathews

Oil on canvas, 48 x 52

Private Collection

Initially trained as an architect in his family's practice, Mathews later traveled to Paris, entered the Académie Julian and, from 1885 to 1889, studied under Gustave Boulanger and Jules Lefebvre. In 1890 he was appointed director of the California School of Design, San Francisco, and in 1906 he co-founded The Furniture Shop with his wife, Lucia, and John Zeile. Specializing in interior design, projects in city planning, writing, and small-press publications, The Furniture Shop served as a forum for the dissemination of Mathews' ideas and formulated the basis of what later became known as the California Decorative style.

Ladies on the Grass demonstrates Mathews' preoccupation with the female form, decorative compositional devices, flattened planes of muted color, and simplified arrangements. The solidity and modeling of his figures, reinforced by his Parisian training, reflects his debt to Greco-Roman classicism; the decorative simplicity recalls Oriental art and the muted Arcadian allegories of Puvis de Chavannes.

Marion Kavanagh Wachtel

1876–1954

89.

Summer Afternoon, about 1912

Marion Kavanagh Wachtel

Watercolor on paper, 20¼ x 30⅜
Signed (lower left): Marion Kavanagh
Wachtel 9

Marion Kavanagh Wachtel traveled
throughout the California countryside
with her husband, the painter Elmer
Wachtel. They were among the first artists
to concentrate on the local landscape to
the exclusion of European subjects. They
made their home on the Arroyo Seco near
Pasadena.

Marion Kavanagh Wachtel was much
praised for her watercolors, a medium in
which she worked almost exclusively.
After her husband's death in 1929, she
stopped painting for several years. She
began to paint again around 1932, and
thereafter worked only in oils. The subject
of this watercolor is the Santa Paula Val-
ley near Santa Barbara.

American Arts & Crafts School

90.

Tablecloth

American Arts & Crafts School

Embroidered linen, 95 x 84
Signed (underneath, at edge): C. Campbell

Prints

Posters

Illustrated Books

Photographs

Prints

The etching revival and the rise of a distinguished school of American wood engravers during the late nineteenth century had given hope for new and creative directions in American printmaking. By the turn of the century, however, both movements had run their course. Most of the major figures of the etching revival had died or were working in other media; fine wood engraving had been supplanted by new photomechanical techniques. The art market was flooded, during this period, with large, uninspired etchings by both American and European artists that were highly touted as "fine art," but were in fact elaborate, overworked potboilers produced in large editions by commercial printers. The situation would, in time, encourage a productive response among a number of artists. Just as Gustav Stickley and other leaders of the Arts & Crafts Movement were beginning to denounce the current production of ill-designed, ornate pastiches of earlier forms of decorative arts, printmakers and other artists turned from the meretricious to develop new aesthetic criteria and revitalized values. Many found sources of fresh inspiration in the art of Japan.

American knowledge of the art of Japan had grown steadily between the 1876 Centennial Exposition in Philadelphia, where the elaborate Japanese pavilions had excited much interest, and similar displays at the 1893 World's Columbian Exposition in Chicago. The simplicity and refinement of form and color in Japanese woodcuts of the Ukiyo-e School were widely admired.

By 1900, however, the Japanese techniques of cutting multiple blocks with proper registration and handling watercolors in the inking, wiping, and printing stages were not commonly known. In this respect, Arthur Wesley Dow, as both an artist and a teacher, was an important resource for a number of artists.

Born in Ipswich, Massachusetts, Dow studied in Boston and worked between 1884 and 1889 at the Académie Julian in Paris and at Pont Aven in Brittany. Dissatisfied with entrenched classical traditions, he looked to other artistic doc-

trines. His discovery of Hokusai and his important meeting with Ernest Fenollosa, then curator of Oriental art at the Museum of Fine Arts, Boston, drew him to the art of the East. By drawing in sumi ink, in emulation of Chinese and Japanese drawings, and becoming increasingly familiar with Japanese color woodcuts, Dow developed a simplified style of painting in which traditional modeling in chiaroscuro and perspective were eliminated in favor of compositions conceived in flat, decorative areas of color. For Dow, the basic elements of design became line, color, and *notan* (the Japanese term for the arrangement of darks and lights). With Fenollosa's support, Dow began to apply these same tenets to his work in color block prints around 1893. In 1895 Dow's new woodcuts were showcased in an important exhibition at the Museum of Fine Arts.

Dow's color woodcuts and his important and often reprinted book on design principles, *Composition* (first published in 1899), significantly altered the development of art instruction in this country. A dedicated teacher, Dow took the position of an idealistic crusader for reform in art and life, a position not unlike that of many other spokesmen for the Arts & Crafts Movement. As he stated to a group of students:

Teach a child to know beauty when he sees it, to create it, to love it, and when he grows up he will not tolerate the ugly. In the relations of lines to each other he may learn the relations of lives to each other; as he perceives color harmonies he may also perceive the fitness of things....*

Unlike Dow, many of the artists interested in working in color woodcuts in a modified Japanese manner were dependent on technical articles which, fortunately, appeared with growing frequency in periodicals such as *The International Studio*, *The Craftsman*, and other publications with a strong Arts & Crafts orientation. It is apparent from a survey of the numerous articles on Japanese prints published in these journals early in the century that the work was seen to be empathetic to the ideals of the new generation of artisans.

There were some artists, such as B.J.O. Nordfeldt, who learned the craft of color woodcuts in Europe, while a surprising number of artists, including several enterprising women such as Bertha Lum, made extended visits to Japan to study all phases of block printing. The works of these and other artists emulated the Japanese mode, but were not slavish imitations; with growing expertise, artists developed independent stylistic directions. By 1915, a flourishing and diverse school of artists working in color woodcuts had been established in the United States.

The work of many of these artists stood in direct contrast to the rather predictable, black-and-white etchings then currently in favor; in their honest directness and restrained ornamentation they were closer to the tenets of the Arts & Crafts Movement. In addition, there was a shared recognition of the unique qualities inherent in materials and how they might be most appropriately handled. For instance, in many of the color woodcuts, such as Bertha Lum's *Point Lobos* (cat. 93), the fine grain of the wood is deliberately allowed to show through the transparent color and assumes true aesthetic importance. Furthermore, the wood, in cutting, presented a resistance that encouraged simplicity and an emphasis on color and design, rather than on descriptive line, an approach in keeping with the formal concepts and interests of the new decorative movement. In many respects, American color woodcuts embodied those Arts & Crafts doctrines that stressed truth to materials and a desired integration of inspiration and craftsmanship. Indeed, these woodcut artists of the first decades of the twentieth century were as much artisans as artists.

JANET A. FLINT

*Quoted in Frederick C. Moffatt, *Arthur Wesley Dow* (Washington, D.C.: Smithsonian Institution Press, 1977), pp. 62–63.

Arthur Wesley Dow

1857–1922

91.

The Derelict (The Lost Boat), 1916

Color woodcut, 5³/₄ x 4
Inscribed (lower right): The Derelict, 1st
proof, Feb. 6, 1916

Pedro J. Lemos
1882–1945

92.

Where Tree and Ocean Meet, about 1920

Color woodcut, $8^1/_{16}$ x $7^3/_8$
Signed (lower right): Pedro J. Lemos

Pedro Lemos was born in Austin, Nevada, in 1882. His formal training included studies with Arthur Wesley Dow and classes at the San Francisco Institute of Art. A painter and printmaker, Lemos was also active as an illustrator, craftsman, writer, and teacher.

Bertha Lum
1879–1954

93.

Point Lobos, 1920

Color woodcut, $16^1/_8$ x $10^5/_8$
Signed (lower center): Bertha Lum

Born in Iowa, Bertha Lum studied at the School of the Art Institute of Chicago. Her first trip to Japan (on her honeymoon) was made at the turn of the century. She periodically returned there to study the art of woodblock printing and to participate in exhibitions. Eschewing the traditional Japanese division of labor between artist, cutter, and printer, Lum took responsibility for the entire process, from inception to final impression. Many of her finest woodcuts depict landscapes along the California coast, such as *Point Lobos*, which combine elements of traditional Oriental art with stylized forms of Art Nouveau.

Bror Julius Olsson Nordfeldt

1878–1955

94.

The Long Wave, about 1905

Color woodcut, 7¹/₂ x 14³/₄
Signed (lower right): artist's chop

Painter and printmaker, Nordfeldt left his
native Sweden in 1891 and settled with
his family in Chicago. After studying
briefly at the School of the Art Institute,
he went to Europe in 1900 and from there
to England in order to study color wood-
cut printing with Frank Morley Fletcher,
the leading English exponent of Japanese
techniques. Nordfeldt's subsequent work
in this manner earned him the silver medal
for block prints at the International Print
Exhibition in Milan in 1906.

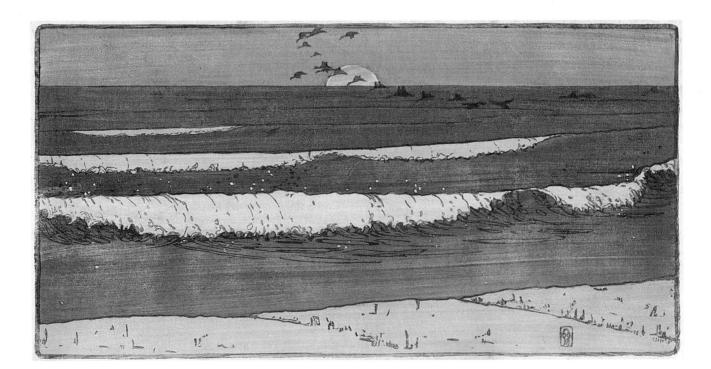

Margaret Jordan Patterson

1867–1950

95.

In the High Hills, about 1925

Color woodcut, 11¼ x 8⅞
Signed (lower right): Margaret J.
Patterson

In the 1890s, Patterson's training included
studies with Arthur Wesley Dow at Pratt
Institute in New York and with Charles
Herbert Woodbury in Boston. She later
continued her study of color block prints
in Paris with Ethel Mars. Although per-
haps best known for her flower studies,
she also created a number of landscapes
during the 1920s, including several bril-
liantly colored works such as *In the High
Hills*.

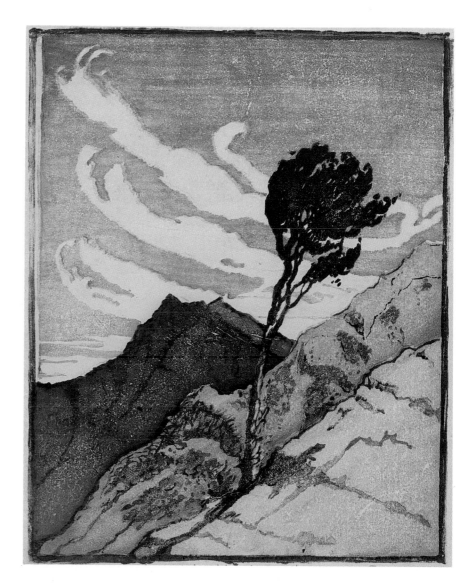

Posters and Illustrated Books

The golden age of American book design occurred at the turn of the century with the revival of fine printing encouraged by the spread of the Arts & Crafts Movement. From 1890 to 1905, the graphic arts blossomed, fostered by an aesthetic philosophy which sought to elevate the status of the craftsman to that of the fine artist. Spurred by the success of the "little magazines" and private literary presses of the day, bookmaking achieved a status it had not known since the Renaissance.

The publication in 1891 of *Story of the Glittering Plain* by William Morris' Kelmscott Press was the catalyst for the development of an Arts & Crafts style of bookmaking in America. The work of the Kelmscott Press was guided by the same principles that came to define the Arts & Crafts Movement as a whole—unity of design and manufacture, integrity of materials, and a reverence for historical idioms.

The various characteristics that define the Arts & Crafts book were adopted from the earliest Western printed books, which, in turn, had attempted to imitate the appearance of medieval manuscripts. The materials employed often included handmade laid paper with deckle edges, heavy black ink, and a second color ink for titles and rubricated initials. Bindings might be of limp or stiff vellum with silk ties or blindstamped leather.

With respect to design, modern typefaces were eschewed in favor of heavier, older styles, with Gothic a favorite for display application. The title page and text were often designed as a double opening, to be seen as a single unit. Typically, initials and ornaments were woodcuts and employed arabesque or foliate tracery and Gothic type. Text was arranged in blocks, the lines closely spaced, and flush both left and right with fleuron line fillers. Production was limited to small editions, often numbered and signed by the artisans involved. The emphasis on craftmanship could be felt in the heavy inking and intentionally firm type impression, which was left as the signature of hand presswork.

Copeland & Day of Boston was the first publishing firm in America to specialize in the Arts & Crafts book. (A close

friend of both Oscar Wilde and John Keats, the eccentric F. Holland Day was also a master photographer.) Along with Stone & Kimball of Chicago, Copeland & Day were among the many literary publishers—small presses started by a young generation with a passion for modern literature.

For these firms, and the designers they employed, the making of fine books fulfilled two ideals central to the Arts & Crafts Movement. Publishing allowed them to disseminate the works of the writers they admired, introducing literature in an aesthetic format to the common man. In addition, by striving to produce books whose design and production were in total harmony with their content, these presses served to elevate the status of bookmaking. A printer's creation, if it achieved communion with the spirit of a writer's work, was seen as an equivalent artistic endeavor.

The first Copeland & Day book design to see publication was Dante Gabriel Rossetti's *The House of Life* (1894). The decorations, showing a strong Kelmscott influence, were provided by the principal designer for the firm, Bertram Grovesnor Goodhue (cat. 110).

The magazine *Modern Art*, founded by J.M. Bowles in 1893, was one of the most influential art journals to spread the Arts & Crafts message. Bowles moved from Indianapolis to Boston in 1895 after arranging to have the magazine financially backed by the finest lithography firm in the country, Louis Prang & Co. Prang's masterful reproduction of Arthur Wesley Dow's color woodcut *Sundown, Ipswich River* was used by Bowles to advertise the first Boston volume of the magazine (cat. 100).

By 1900, dozens of small presses had sprung up, modeled on the example of Kelmscott. One of the very best, the Elston Press, was begun by Clarke Conwell in New York City and later relocated to New Rochelle. Conwell's wife, Helen Marguerite O'Kane, provided much of the graphic design for the firm. The limited production of the Elston Press was of consistently outstanding quality, characterized by bold design, faultless presswork, and sumptuous handmade papers (cat. 103).

One publisher managed to introduce the Arts & Crafts book to more Americans than most of his peers combined by utilizing mail order as his primary means of sales. Elbert Hubbard's Roycroft Press in East Aurora, New York, flourished from its establishment in 1895 until its founder went down with the *Lusitania* in 1915. Although the Roycroft craftsmen turned out a variety of products, including furniture, leather goods, and copperware (cats. 2, 3), printing was the mainstay of their workshops. Of all the book designers associated with the Roycrofters, the one to garner the greatest acclaim was a talented young man from Chilicothe, Ohio, Dard Hunter. Hunter became famous for his "one-man books," which epitomize the Arts & Crafts ideal. They began with Hunter's own manuscript, which would be set in type he designed and fabricated. Following his own layout, he would then compose each page and print it on paper he had made by hand.

The elongated, rectilinear Art Nouveau forms favored by the Vienna Secessionists can be recognized in much of Hunter's work, as in his designs for Ralph Waldo Emerson's *Nature*, 1905 (cat. 105) and Hubbard's *White Hyacinths*, 1907 (cat. 108). His *Justinian and Theodora*, 1906 (cat. 107), is considered the finest book produced by the Roycrofters.

Chicago was also a center of fine printing at the turn of the century, and numerous private presses in the vicinity made a specialty of the Arts & Crafts book. The Blue Sky Press was founded in 1899 with publication of the arts and literature magazine *Blue Sky*. The founders, A.G. Langworthy and T.W. Stevens, managed to produce a noteworthy series of handmade, limited edition books which reflect the three stylistic currents of the day: Aesthetic, Art Nouveau, and Arts & Crafts. *The Harper & The King's Horse*, by E. Payne Erskine, is typical of their work (cat. 106).

Ralph Fletcher Seymour was an important figure in Chicago publishing around 1900. His inspiration came direct from exposure to the works of William Morris and the Kelmscott Press. Seymour's design for Keats' *The Eve of St. Agnes* is charming, if not facile, and the heavy woodcuts and Gothic type fall squarely within the Arts & Crafts tradition (cat. 109).

One of the giants of American book design of this time was Will H. Bradley, a master of the Art Nouveau style and one of the most influential figures in early-twentieth-century American printing. Bradley received his early training in the printing arts while in the employ of a number of different firms in and around Chicago. He initially gained wide recognition for his posters for Stone & Kimball's *Chap-Book*, the first of the so-called little magazines (cats. 96, 97).

In 1895, Bradley moved east to set up the Wayside Press in Springfield, Massachusetts. His artistic and literary magazine, called *Bradley—His Book*, ran for seven numbers in 1896–97 and firmly established his reputation as the most original American typographer of his day (cat. 102). Bradley's design for Stephen Crane's *War Is Kind* is considered his masterwork and the finest example of the Art Nouveau book crafted in America (cat. 104).

The fine printing revival was slow in reaching the West. With the exception of Elder & Shepard in San Francisco, it would not come into its own until the celebrated printer John Henry Nash achieved prominence immediately after World War I. However, there were some outstanding artists employed to provide graphics for local publications at the turn of the century. Among them, the work of Florence Lundborg (cat. 101) and Maynard Dixon (cat. 99) reveals the influence of the Arts & Crafts sensibility.

American book design reached its greatest heights under the philosophical and aesthetic inspiration of the Arts & Crafts Movement. As a distinct style, the Arts & Crafts book would flourish and then fade within fifteen years of its introduction, as the Gothic Revival style was abandoned in favor of the lighter, classical types. The legacy of this brief but intense period survives to this day, however, in the vitality of the small presses dedicated to fine printing all across America, and in our recognition of their splendid craft as an art.

JOSEPH GODDU

Will H. Bradley

1868–1962

96.

The Chap-Book, 1895

Publisher: Stone & Kimball, Chicago
Lithograph, 19⁷/₈ x 13³/₈

Also known by the title *Pegasus*, this was
the sixth poster designed by Bradley for
The Chap-Book, and it appeared in Sep-
tember 1895.

97.

The Chap-Book, 1895

Publisher: Stone & Kimball, Chicago
Lithograph, 19 1/2 x 12 3/8

This is the third poster designed by Bradley for *The Chap-Book*. Issued in January 1895, it reveals a decided Kelmscott influence. The poster is also known by the title *Poet and His Lady*.

98.

Bradley—His Book, 1896

Publisher and printer: Wayside Press, Springfield, Massachusetts
Color woodcut and lithograph, 39 7/8 x 27

Bradley's poster, also known as *The Kiss*, was his first design for a series advertising his periodical, *Bradley—His Book*, and it is an outstanding example of how effortlessly he was able to combine a variety of influences to create a unique product. The image of a woman with a peacock was a popular Pre-Raphaelite motif, which Bradley rendered with the curvilinear line of the English artist Aubrey Beardsley and set within a Kelmscott border and type.

Lafayette Maynard Dixon

1875–1946

99.

Sunset—The Pacific Monthly Magazine, 1902

Publisher: Sunset, San Francisco
Color lithograph, 23 1/8 x 13 1/4

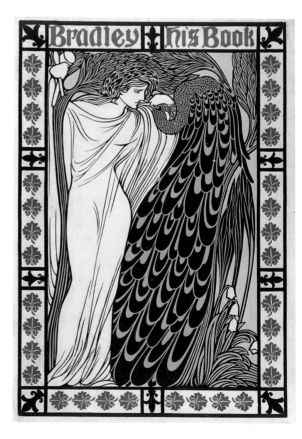

Arthur Wesley Dow

1857–1922

100.

Modern Art, 1895

Publisher and printer: Louis Prang & Co., Boston
Color lithograph, 17⅞ x 13⅝

Dow's masterful color woodcuts, like the one reproduced here by J.M. Bowles to advertise his journal *Modern Art*, were the perfect embodiment of the Arts & Crafts ideal of the unification of art with craft.

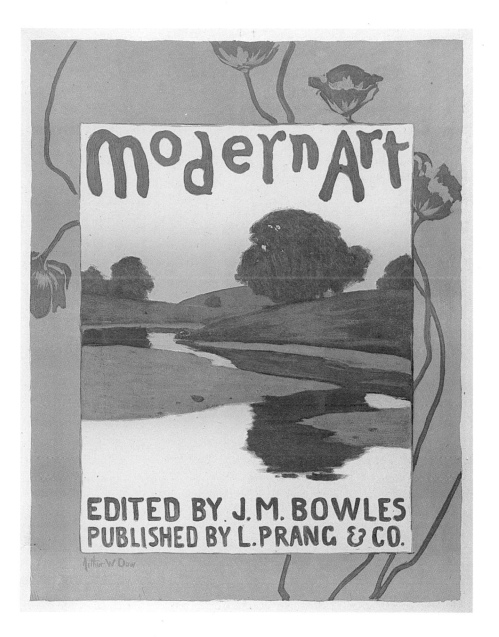

Florence Lundborg

1871–1949

101.

The Lark/November, 1895

Publisher: William Doxey, San Francisco
Color woodcut on Japanese paper, 16³/₈ x
9⁷/₈

Florence Lundborg provided seven poster
designs for *The Lark*, a San Francisco
humor and literary magazine, between
1895 and 1897. In keeping with Arts &
Crafts principles, she composed and cut
her own design in wood, achieving a
satisfying unity of medium and Japonisme
design. The scene depicts a local land-
mark, Mt. Tamalpais, in Marin County.

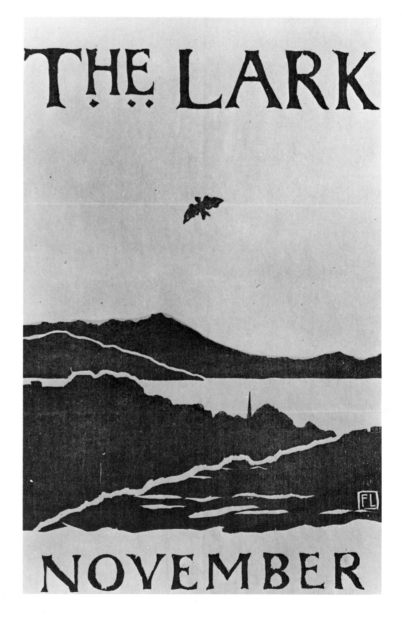

Will H. Bradley

1868–1962

102.

Bradley—His Book, vol.I, no. 1, 1896

Publisher and printer: Wayside Press, Springfield, Massachusetts
Colored inks on white paper, gray wove cover, 9⁷/₈ x 5

Bradley's journal earned him immediate acclaim as the most original of the American typographers. This outstanding first issue, dramatic in its design and use of color, is typical of the series.

103.

Stephen Crane, *War Is Kind*, 1899

Publisher: Frederick A. Stokes, New York
Printer: The University Press, Cambridge, Massachusetts
Black ink on gray paper, 8¹/₄ x 5

Bradley provided both the artwork and the layout for the first edition of *War Is Kind*. The elegant illustrations in the Art Nouveau manner offer a powerful counterpoint to Crane's impassioned text and successfully meld stylistic elements from a variety of sources, including Aubrey Beardsley and Charles Ricketts.

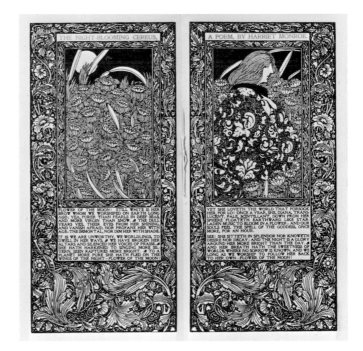

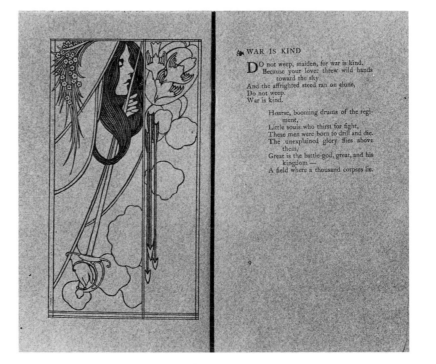

Helen Marguerite O'Kane

104.

Elizabeth Barrett Browning, *Sonnets from the Portuguese*, 1900

Publisher and printer: Elston Press, New York
Black ink on Imperial Japanese paper, 10¼ x 8
Modern limp English vellum binding by Judith Ivry, with gilt decoration on binder's thongs, double-ribbon tie closing.

This was the first production of Clarke Conwell's Elston Press and features the dramatic design of his wife, Helen O'Kane. Although only twenty-one at the time of publication, she combined her own bold decorations and the heavy Satanick type with remarkable assurance to produce a masterpiece of Arts & Crafts bookmaking.

Dard Hunter

1883–1966

105.

Ralph Waldo Emerson, *Nature*, 1905
Publisher and printer: The Roycrofters, East Aurora, New York
Red and black inks on white paper, 8⅛ x 5¼

Thomas Wood Stevens

1880–1942

106.

E. Payne Erskine, *The Harper & The King's Horse*, 1905
Publisher and printer: Blue Sky Press, Chicago
Illustrator: Sarah K. Smith
Black and red ink on white paper, 9⅛ x 6

Dard Hunter

1883–1966

107.

Elbert and Alice Hubbard, *Justinian and Theodora*, 1906

Publisher and printer: The Roycrofters, East Aurora, New York,
Black and orange ink on white paper, 7³/ x 5³/₄

Hunter kept up with the latest art journal from Vienna and Glasgow during his tenure in East Aurora. His *Justinian and Theodora* reveals those influences and is considered by many to be the Roycroft masterpiece of bookmaking.

Dard Hunter

1883–1966

108.

Elbert Hubbard, *White Hyacinths*, 1907

Publisher and printer: The Roycrofters, East Aurora, New York
Black, green and light red inks on white paper, 7 x 4¹/₂

Ralph Fletcher Seymour

1876–1966

109.

John Keats, *The Eve of St. Agnes*, 1900

Publisher: Ralph Fletcher Seymour
Printer: R.R. Donnely & Sons
Black and sienna inks on white paper,
8⁷/₈ x 5¹¹/₁₆

Bertram Grovesnor Goodhue

1869–1924

110.

Dante Gabriel Rossetti, *The House of Life*, 1894

Publisher: Copeland & Day, Boston
Printer: The University Press, Cambridge, Massachusetts
Black ink on white paper, 8¹/₂ x 6³/₈

The was the first book published by Copeland & Day and one of the earliest American productions to emulate the Kelmscott style. It is set in a type called Bookman, whose heavy weight complements Goodhue's masterful woodcut decorations.

Photographs

Alfred Stieglitz had a mission to establish photography as a medium of artistic expression. A zealous proselytizer who rarely catered to popular taste or opinion, Stieglitz founded a magazine to promote his cause. *Camera Work* (1903–17), unlike some of the more glamorous magazines of the period, functioned aggressively as an aesthetic and theoretical journal. If Stieglitz had lofty notions about photography's potential, *Camera Work*, with its editorial emphasis on international, vanguard photography and critical text, was a perfect vehicle for his missionary objectives.

Stieglitz had a remarkable eye for recognizing serious photographic work. His central criteria were technical finesse and formal invention, and his support of various photographers, some of whom were initially brought to his attention by Edward Steichen and F. Holland Day, was in no way restricted by nationality. One has only to glance through the pages of *Camera Work* to realize the extent to which photography had permeated the cultural fabric of Europe and America between the years 1903 and 1917. A born leader who loved being at the center of change and controversy, Stieglitz found strength in numbers. But the Society of the Photo-Secession, as his group of dedicated art photographers came to be called, needed more than initiates and an international membership to convince a skeptical public that the camera was capable of producing great things.

Initially, most people found it hard to take photography seriously. Here was a mechanical medium that could faithfully record reality, but where were its "artistic" qualities? How could its flat, strangely cropped images achieve the kind of poetry, imagination, and touch that distinguished traditional modes of painting and sculpture? There was also the problem of association with an ever-growing number of amateurs—"button pushers"—and an industry named Kodak that, by 1888, had marketed a portable camera whose prints cost about 10 cents to develop. In some ways, early art photographers, like Arts & Crafts furniture makers, were caught in a paradoxical bind. Given their concern for craftsmanship and

personalized design, how could they humanize and aestheticize the very machines that made their art possible? In the case of photography, the irony of this situation was particularly poignant, and early on its practitioners looked for ways to compensate for, and mask, the camera's inherent mechanisms. If some photographers opted to emulate the rich tonal range and pictorial effects of contemporary printmaking, others pursued a "straight" approach, eschewing manipulation and tonal blur for pristine images, "snapshots" taken directly from nature. In *Camera Work*, Stieglitz not only presented a democratic cross-section of these approaches, but he also published articles that complimented the images by providing critical analysis and explanation.[1] Ultimately, what united all art photographers was their concern for technique, craft, and the presentation of their prints.

Many art photographers worked in the manner of Arts & Crafts furniture makers, metal workers, and ceramicists, who took pride in the quality of their products and designed markings that would ensure their authorship and authenticity. They were not only fastidious about their materials and chemistry, but also bestowed great attention on the print itself as well as its mat, mount, frame, and signature. Such formal procedures were not just tacitly accepted; they were addressed and debated in the pages of *Camera Work*.[2] Within the art photographer's worldview, everything had relevance, both within and outside the frame. Unity of design, the total orchestration of compositional elements to create a harmonious whole—whether the photographic image within a Secessionist platinum, silver, or gravure print, the landscaped grounds and rustic interior of a Stickley bungalow, or an Arthur Wesley Dow colored woodblock print—became, in the Arts & Crafts sensibility, an axiom having cosmological overtones.

If industry and machines by the first decade of the twentieth century threatened to disrupt the equilibrium between man and his natural environment, photographers responded to the situation either by escaping through fantasy and history or by finding ways to explain and order that which seemed to be getting progressively more fractured and chaotic. The strange marriage between science and mysticism during these years may explain why some photographers—F. Holland Day, George Seeley, Annie Bridgman, Clarence White, and Edward Steichen—endowed their meticulously made pictures with a mysterious and transcendent light, blurred textures and tones, and pursued subjects whose apparent timelessness and contemplative character in some cases seemed like ciphers for higher levels of consciousness; it may also explain why others —Stieglitz, Paul Strand, and Alvin Langdon Coburn—through direct and unmediated images of urban growth and power, embraced change on all fronts, the present as well as the future.

Content was a matter of personal choice, but certain themes derived from non-photographic sources were more prevalent than others. We know that many Arts & Crafts architects and designers initially looked to Europeans—William Morris, C.F.A. Voysey, and Charles Rennie Mackintosh —for inspiration and direction, all the while espousing the necessity of producing an indigenous American product. Such has been the history of American art since Benjamin West. But early art photographers were less averse to European affiliations and influences. Emulating the work of the English Pre-Raphaelites, James Abbot McNeill Whistler, the French Symbolists, or Barbizon School was not only acceptable, but, in fact, *au courant*. So was a fascination with Japonisme. After all, photography in its youth had to measure itself against something. By the first issue of *Camera Work*, however, another, more grass-roots sensibility had emerged. Gertrude Käsebier and Clarence White both came from rural outposts. Käsebier was born in Iowa; White in Ohio. Both fostered a healthy respect for agrarian values, home, and the family. Their pictures, which certain critics noted for their "emotional intensity" and "provincialism," elevated maternity and domesticity above artifice and experimentation.[3] Their work issued from the same humanitarian spirit that motivated Stickley to design his Craftsman homes with spacious living rooms for

large family and social gatherings, and signaled a culture moving beyond the noisy congestion of large urban centers into the rural American landscape.

If America could lay claim to only a few indigenous subjects, the Indian was certainly one of these. An authentic American people with their own rites and mythology, the Indians symbolized a community at one with nature. Given their unpretentious simplicity—their "primitivism"—and the fact that their future by the turn of the century was already in jeopardy, Indians were easily romanticized. Their plight became grist for journalists and photographers alike. *The Craftsman* published articles on Hopi cliff dwellings and religious festivals;[4] Käsebier and Edward Curtis documented the fading grandeur of once great tribes. The figures in Käsebier's series of Indian portraits, taken about 1898, were actually members of Buffalo Bill Cody's roving troupe, whom she persuaded to pose for her in her studio. The irony of these allegedly authentic pictures poignantly reflects the depressed state of Indian culture by this time.

By the time Stieglitz discontinued the publication of *Camera Work* in 1917, photography no longer needed a defense, and with the gradual dissolution of the Photo-Secession after 1910, most photographers went their independent ways. Stieglitz began devoting more time to his own work and promoting the art of Georgia O'Keeffe, John Marin, Arthur Dove, and Marsden Hartley, all painters who became part of Stieglitz's staple at An American Place. Stieglitz's own work underwent a significant change: the international orientation and urban emphasis of his earlier photographs gave way in the 1920s to a staunchly defined and defended American vision grounded in the landscape. For Stieglitz, as well as his inner circle of painters and writers, including Paul Rosenfeld and Waldo Frank, nature became the matrix for a truly American art.

Nature had also been the matrix that united various tenets within the American Arts & Crafts Movement. Nature signified a system that was grounded and holistic rather than compartmentalized and specialized, and architects and designers vehemently fought to preserve and perpetuate the notion of totality and unity. Within this organic orientation, the machine was a blessing as well as a curse. Its efficiency and practicality was certainly acknowledged and utilized, but its presence—its mechanistic implications—introduced a tension that was hard to reconcile with the movement's aesthetic and philosophical beliefs. Caught in a quandary, most Arts & Crafts practitioners as well as photographers (with the possible exception of Frank Lloyd Wright), straddled the fence between history and the future. Reacting against the excessive ornamentation of the Beaux-Arts-inspired American Renaissance, they confronted the usable past with the uncertain future. If some of their work seems as vital today as it did originally, it is because many of the questions it raises are still worth considering.

DOUGLAS DREISHPOON

1. See, for example, Robert Demachy, "The Gum-Print," *Camera Work*, no. 7 (July 1904), pp. 33–37; Sidney Allan, "The Technique of Mystery and Blurred Effects," *Camera Work*, no. 7 (July 1904), pp. 24–26.

2. Eva Watson-Schutze, "Signatures," *Camera Work*, no. 1 (January 1903), pp. 35–36; Sidney Allan, "The Influence of Artistic Photography on Interior Decoration," *Camera Work*, no. 2 (April 1903), pp. 31–33.

3. Charles H. Caffin, "Mrs. Käsebier's Work—An Appreciation," *Camera Work*, no. 1 (January 1903), pp. 17–19; Frances Benjamin Johnston, "Gertrude Käsebier, Professional Photographer," *Camera Work*, no. 1 (January 1903), p. 20; Giles Edgerton [Mary Fanton Roberts], "Photography as an Emotional Art: A Study of the Work of Gertrude Käsebier," *The Craftsman*, 12 (April 1907), pp. 80–93; Charles H. Caffin, "Clarence H. White," *Camera Work*, no. 3 (July 1903), pp. 15–17; George Bicknell, "The New Art in Photography: Work of Clarence H. White, A Leader among the Photo-Secessionists," *The Craftsman*, 9 (January 1906), pp. 495–510.

4. Frederick Monsen, "Pueblos of the Painted Desert: How the Hopi Build Their Community Dwellings on the Cliff," and "Festivals of the Hopi: Religion the Inspiration, and Dancing an Expression in All Their National Ceremonies," *The Craftsman*, 12 (April–September 1907), pp. 16–33, 269–85.

Edward Sheriff Curtis

1868–1952

III.

A Point of Interest—Navaho, 1904

Gravure print, 10³/₈ x 14¹/₂

Inscribed (along the bottom): A POINT
OF INTEREST—NAVAHO From
Copyright Photograph 1904 by E.S. Cur-
tis Photogravure John Andrew & Son

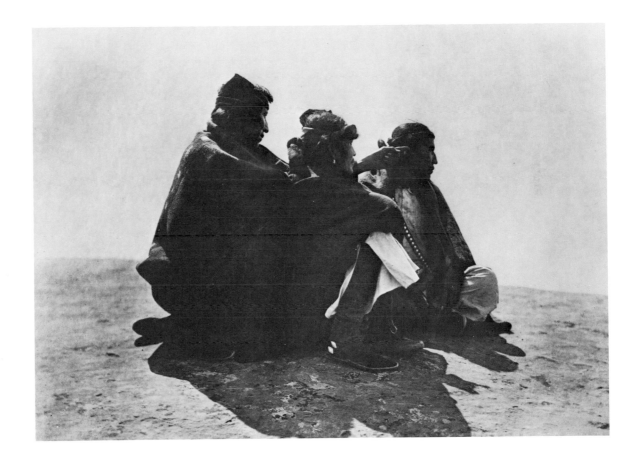

Gertrude Käsebier

1852–1934

112.

Happy Days, about 1905

Gravure print, 8 x 6¹/₂

RECORDED: *Camera Work*, no. 10
(April 1905), p. 11 illus.

George H. Seeley

1880–1955

113.

The Black Bowl, about 1907

Gravure print, 8¹/₄ x 6¹/₈

RECORDED: *Camera Work*, no. 20
(October 1907), p. 7 illus.

Alfred Stieglitz

1864–1946

114.

Snapshot—In the New York Central Yards, about 1903

Gravure print, 8 x 6⅝

RECORDED: *Camera Work*, no. 20 (October 1907), p. 45 illus.

Clarence H. White

1871–1925

115.

The Orchard, about 1905

Gravure print, 8¼ x 6⅛

RECORDED: *Camera Work*, no. 9 (January 1905), p. 5 illus.

Bibliography

Billcliff, Roger. *Charles Rennie Mackintosh: The Complete Furniture, Furniture Drawings & Interior Designs*. London: Cameron & Tayleur, 1979.

Boston, Museum of Fine Arts. *"The Art That Is Life": The Arts & Crafts Movement in America, 1875–1920* (exhibition catalogue), 1987. Edited by Wendy Kaplan.

Cathers, David M. *Stickley Craftsman Furniture Catalogs*. New York: Dover Publications, 1979.

———. *Furniture of the American Arts and Crafts Movement*. New York: The New American Library, 1981.

Clark, Garth. *American Ceramics, 1876 to the Present*. New York: Abbeville Press, 1987.

Darling, Sharon S. *Chicago Metalsmiths*. Chicago: Chicago Historical Society, 1979.

Erie, Pennsylvania, Erie Art Museum. *Frederick Hurten Rhead: An English Potter in America* (exhibition catalogue), 1986. Catalogue by Sharon Dale.

———. *Teco: Art Pottery of the Prairie School* (exhibition catalogue), 1989. Catalogue by Sharon S. Darling.

Fort Worth, Amon Carter Museum of Western Art. *Greene & Greene: Architects in the Residential Style* (exhibition catalogue), 1974. Catalogue by William R. Current and Karen Current.

Gill, Brendan. *Many Masks: A Life of Frank Lloyd Wright*. New York: G. P. Putman's Sons, 1987.

Grand Rapids Art Museum, Michigan. *Arts and Crafts Furniture Design: The Grand Rapids Contribution* (exhibition catalogue), 1987. Catalogue by Don Marek.

Gray, Stephen, ed. *A Catalog of the Roycrofters*. New York: Turn of the Century Editions, 1989. Reprint.

Gray, Stephen, and Robert Edwards, eds. *Collected Works of Gustav Stickley*. New York: Turn of the Century Editions, 1981. Reprint.

Gray, Stephen, and Kenneth R. Trapp, eds. *Arts and Crafts Furniture: Shop of the Crafters at Cincinnati*. New York: Turn of the Century Editions, 1983. Reprint (1983a).

———. *The Mission Furiture of L. & J.G. Stickley*. New York: Turn of the Century Editions, 1983. Reprint (1983b).

_____. *The Early Work of Gustav Stickley*. New York: Turn of the Century Editions, 1987. Reprint.

Hanks, David A. *The Decorative Designs of Frank Lloyd Wright*. New York: E. P. Dutton, 1979.

Henzke, Lucile. *Art Pottery of America*. Exton, Pennsylvania: Schiffer Publishing, 1982.

Hitchcock, Henry-Russell. *In the Nature of Materials: The Buildings of Frank Lloyd Wright, 1887–1941*. New York: Da Capo Press, 1942.

Hoffmann, Donald. *Frank Lloyd Wright: Architecture and Nature*. New York: Dover Publications, 1986.

Hubbard, Brady, and Nancy Hubbard, eds. *The Book of the Roycrofters*. East Aurora, New York: House of Hubbard, 1977. Reprint.

Johnson, Bruce. *The Official Identification and Price Guide to Arts and Crafts*. New York: House of Collectibles, 1988.

Kiehl, David. *American Art Posters of the 1890's in The Metropolitan Museum of Art, including the Leonard A. Lauder Collection*. New York: The Metropolitan Museum of Art, 1987.

Limbert's Holland Dutch Arts and Crafts Furniture, Charles P. Limbert Company Cabinetmakers. New York: Turn of the Century Editions, 1981. Reprint.

Makinson, Randell L. *Greene & Greene: Architecture as a Fine Art*. Vol. I. Santa Barbara: Peregrine Smith, 1977.

_____. *Greene & Greene: Furniture and Related Designs*. Vol. II. Santa Barbara: Peregrine Smith, 1979.

Manson, Grant Carpenter. *Frank Lloyd Wright to 1910*. New York: Van Nostrand Reinhold, 1958.

Miami Beach, Florida, Bass Museum of Art. *Frank Lloyd Wright: Prints, Drawings, and Decorative Objects* (exhibition catalogue), 1984.

Milwaukee Art Museum. *The Domestic Scene (1897–1927): George M. Niedecken, Interior Architect* (exhibition catalogue), 1982. Catalogue by Cheryl Robertson.

New Haven, Yale University School of Architecture. *The Chairs of Frank Lloyd Wright* (exhibition catalogue), 1987.

New York, Hirschl & Adler Galleries. *Modern Times: Aspects of American Art, 1907–1956* (exhibition catalogue), 1986.

New York, The American Ceramic Arts Society. *From Our Native Clay: Art Pottery from the Collections of the American Ceramic Arts Society* (exhibition catalogue), 1987. Edited by Martin Eidelberg.

Pasadena Art Center, California. *California Design 1910* (exhibition catalogue), 1974. Edited by Timothy J. Andersen, Eudorah M. Moore, and Robert W. Winter.

Poesch, Jessie. *Newcomb Pottery: An Enterprise for Southern Women, 1895–1940*. Exton, Pennsylvania: Schiffer Publishing, 1984.

Princeton, The Art Museum, Princeton University. *The Arts & Crafts Movement in America, 1876–1916* (exhibition catalogue), 1972. Edited by Robert Judson Clark.

Storrer, William Allin. *The Architecture of Frank Lloyd Wright*. Cambridge, Massachusetts: The MIT Press, 1974.

Thompson, Susan Otis. *American Book Design and William Morris*. New York and London: R.R. Bowker Company, 1977.

Ulehla, Karen Evans, ed. *The Society of Arts and Crafts, Boston: Exhibition Record, 1897–1927*. Boston: Boston Public Library, 1981.

Volpe, Tod M., and Beth Cathers. *Treasures of the American Arts and Crafts Movement, 1890–1920*. New York: Harry N. Abrams, 1988.

Index